THE HISTORY

OF

WOOD-ENGRAVING IN AMERICA.

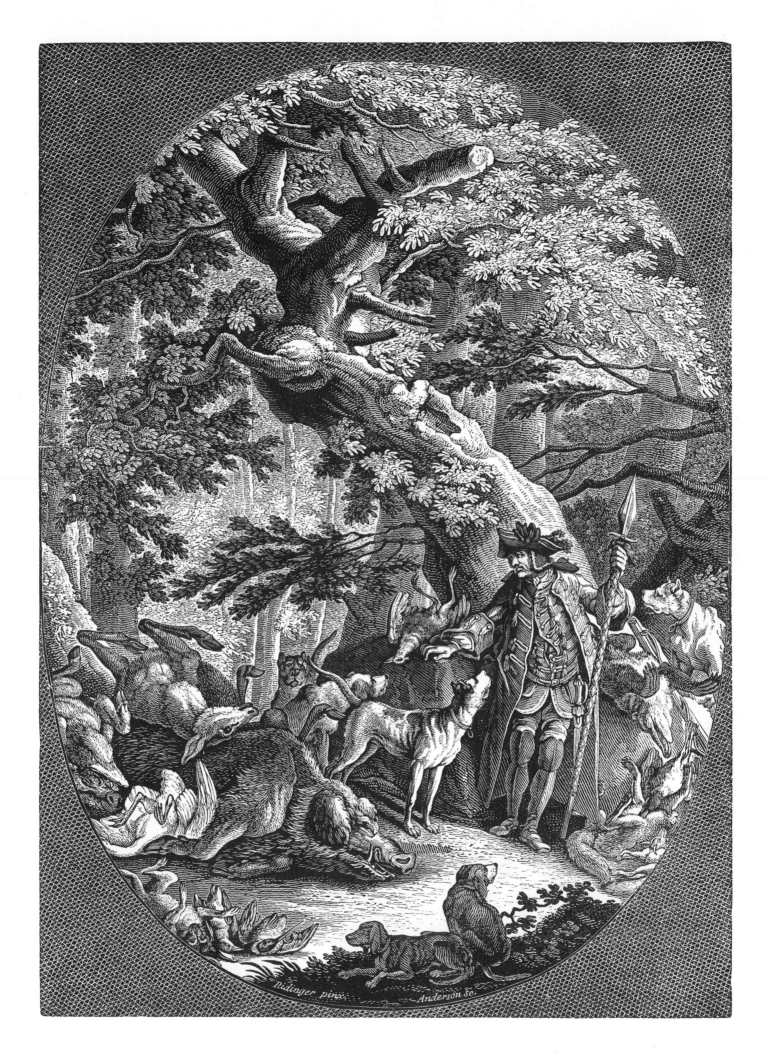

RETURNING FROM THE BOAR-HUNT.

AMERICAN
WOOD ENGRAVING

A Victorian History

William J. Linton

With new index
bibliographies & introduction by
Nancy Carlson Schrock

Published for The Athenæum Library of Nineteenth Century America *by*
THE AMERICAN LIFE FOUNDATION & STUDY INSTITUTE

Watkins Glen, New-York

1976

© 1976 American Life Foundation & Study Institute
Library of Congress Catalog Card Number: 75-22525

The Athenæum Library of Nineteenth Century America is co-published by The Athenæum of Philadelphia and The American Life Foundation; every volume in this series, therefore, bears two ISBNs:

The American Life Foundation
ISBN: 0-89257-010-5

The Athenæum of Philadelphia
ISBN: 0-916530-04-3

Production notes: This new edition was supervised by Walnut Grove Graphic Design & Production Associates in Watkins Glen, New York. New composition of text and display as well as reproduction proofs of same was provided by Tier Oldstyle Typesetting in Binghamton, New York. Printing and binding was done at Valley Offset, Incorporated in Deposit, New York. The text paper is *Finch Opaque* seventy pound weight in a smooth finish. The cover stock of paperback copies is either Weyerhæuser *Andorra* or Strathmore *Rhododendron*. Hardback copies are bound in Holliston *Roxite-C* with endpapers of International *Springhill Index* and dustjackets of *Mead Offset Enamel*.

William James Linton
and his
Victorian History
of
American Wood Engraving

Nancy Carlson Schrock

RACTISING WOOD EN-graving from his appren-ticeship in 1828 until his death in 1897, William James Linton witnessed the development of wood engraving from a crude form of advertising art to the major reproduc-tive process for book and magazine illustration. After a successful career in England, he assumed the rôle of leading American engraver when he emigrated to the United States in 1867. As a skilled and articulate craftsman, he was the ideal author for a history of wood engraving.

Wood engraving was one of several reproduc-tive processes competing for the book illustration and printmaking market in the late eighteenth and early nineteenth centuries. The increasing literacy of the middle class encouraged the technological changes which altered many of the processes in-volved in book production. Inventions such as the continuous papermaking machine (invented in France in 1798 and perfected in England in 1803) and the steam-powered cylinder printing press (first built in England in 1812) produced larger editions more quickly and cheaply. Methods of book illustration kept pace with these advances. Steel engraving, invented in Philadelphia in 1806, supplanted copperplate engraving after 1820. Although more prints could be taken from a plate, each steel engraving took several months to prepare and could cost as much as $250. Lith-ography, discovered in 1798, produced larger editions of prints more cheaply but, like steel en-gravings, lithographs had to be printed separately from the text on special presses. Only wood en-gravings could be printed concurrently with the letterpress. Modified during the nineteenth cen-tury, wood engraving proved economical and ef-ficient enough to meet the needs of book and magazine publications and paved the way for modern book production.

Like the woodcut, wood engraving is a relief process whereby the areas *not* to be printed are cut away, leaving raised sections which print black. Woodcutters had carved planks of wood with knives since the late Middle Ages, but in the 1770s Thomas Bewick of Newcastle-upon-Tyne discovered that he could engrave a far more del-icate line with a burin on the dense end grain of boxwood. The burin, the traditional tool of the copperplate engraver, could be manipulated far more easily than a knife, and the fine lines pro-duced on the end grain could withstand the pres-sure of modern printing presses. These tools and materials prompted a new style of engraving. Bewick evolved a technique called *white line* be-cause he defined his design with the negative space of the wood which had been cut away. Later Eng-lish engravers developed amazing facility with the *black line*, or facsimile technique, which re-tained the original black designs by cutting around the original drawing in imitation of steel en-graving.

Through the years a variety of tools were added to give various effects of tone and line: gravers, tint tools, scoopers, and chisels. Each consisted of a metal shank set into a wooden handle which fit comfortably into the hand of the engraver. Their variations determined the various effects in the wood. Gravers, the basic tool, had lozenge-shaped tips which could be manipulated to create precise lines of varying widths. The straight sides of the tint tools allowed the en-graver to reproduce the fine washes of the orig-inal design with consistently parallel lines. The rounded edges of the scoopers could remove broad areas, while the chisels cut away larger areas and leveled the surface. Each tool was available in a range of sizes.

The early wood engravers were responsible for the original designs as well as their execution, but designers on wood evolved as specialized craftsmen by the early nineteenth century. Until the advent of photography on wood, the designer drew his illustration in reverse directly onto the whitened block in black line and washes. Once the design had been transferred, the engraver placed the block on a sandbag for support. Ma-nipulating various tools, he interpreted the orig-inal drawing as a combination of lines and pat-terns in black and white. Mistakes were corrected by replacing the damaged area with a plug of wood. The work required meticulous attention to detail. Often the engraver would use a magnifying glass and, for night work, a glass globe filled with water to focus light on the block.

Because materials were less expensive and the process less time-consuming, wood engraving could compete with steel engraving. Unlike both steel engravings and lithographs, wood blocks could be printed simultaneously with the text. A single block could withstand over 100,000 im-pressions. The size of an edition became limitless after 1840 when the original blocks were electro-typed. Despite these advantages, publishers were slow to adopt the new method of illustration. In the United States, where Alexander Anderson in-troduced the technique in 1793, few engravers could find work. Much of their early engraving was commercial—labels, handbills, show bills, playing cards, and stock cuts for typefounders.

Steel engraving remained more acceptable for book illustration; magazines and newspapers were largely unillustrated. The style of the early wood engravers was crude but forceful, often in the white line style. They were artisans, working with apprentices and perhaps a partner in major American cities.

After the 1840s, the demand for wood engravers increased. Harper's *Illuminated Bible* (1843) proved that wood engravings could match the quality of steel engravings in books, and the rise of illustrated magazines promoted the growth of the craft. *Harper's Magazine*, established in 1850, employed a full staff of artists and an entire workshop of wood engravers to produce the illustrations needed for each issue of their successful periodical. To create the full page spreads popular during the Civil War, drawings were transferred to many blocks, divided among many engravers, and re-assembled for the final print. Results were frequently mechanical because the work was done under pressure and the goal was an anonymous imitation of the original drawing. The art department was little more than an assembly line to turn out illustrations, and the engraver was separated from the artist.

By 1860 publishing houses had centralized their activities in New York City. So had the wood engravers:

The engravers were usually to be found in the lofts of the old fashioned buildings and dilapidated houses still existing in this part of the city. Most of the Engravers were established in a narrow section. Frank Leslie's Weekly, corner of Elm & Pearl Streets and Harper's Weekly, corner of Cliff and Pearl Streets, employed a great number on the coarser picture work. Smaller firms doing a variety of work were crowded into the upper lofts on the east of Broadway, between John Street south and Spruce Street on the north.[1]

The community of engravers was small enough for them to know each other personally and recognize each other's style. Their work ranged from mechanical reproduction for mail order catalogues and coarse newspaper engraving to the more refined book illustrations. Some freelance engravers worked on a commission basis directly for publishers, while others were employed by engraving firms. One of the largest New York companies was that of John W. Orr. Elbridge Kingsley, later an ardent supporter of the New School of Engraving, worked there and described the firm's operations in 1870:

At the period of greatest activity at 48 Beekman Street we occupied the bulk of two floors. At the entrance was an office, for the proprietor and foreman . . . On the first floor were the artists, and perhaps the apprentices who helped in general ways, from cutting away wood and proving to the running of errands.

The engravers on the upper floor were arranged according to the number of windows and the adaptability of the light. Generally three men to a window seated at a three cornered desk, all facing the light as much as possible. A north light was preferred to any other. Each man's belongings consisted of his set of tools, a sandbag to rest his block upon, an eyeglass in a convenient frame to swing at any angle and focus upon his work. For night work an ordinary fish globe filled with water served to focus the light from a lamp on the block with sufficient intensity. This round spot of intense light was as good as daylight. An oil stone for sharpening the tools, and perhaps a paper shade for the eyes constituted the outfit of the engraver. . . . The engraver was paid by the hour, and his time was kept in a time book to be made up every week.

The proprietor did the delivering and collecting, and also attended to electroplating where required. The wood came in any size and quality from the boxwood man, who had power saws and routing machines for the cleaning up and finishing, so all work began and ended at the boxwood shop.

So the general appearance of an engraving office would be a lot of men in groups of three leaning over the desks, with one eye close to the glass, the left hand holding the block on the pad, and in the right a graver, making textures that would print in reverse.[2]

Such commercialized facsimile work was typical of the state of wood engraving when William James Linton arrived in the United States in 1867. Armed with experience and a reputation as one of the foremost wood engravers in England, Linton quickly assumed a prominent rôle within the engraving community, especially among the younger generation who regarded him as their model. Always eager to champion a cause, Linton sought to elevate the quality of American wood engraving which, in his opinion, had declined below the already debased standards of the art in Europe.

William Linton emigrated to America at the age of fifty-five after a full career in England as political activist, essayist, artist, and wood engraver. Born in London in 1812 to a lower class family, Linton had apprenticed in 1828 to George Wilmot Bonner, a former pupil of Robert Branston who led the London School of wood engraving. During his journeyman years, Linton worked with William Henry Powis and John Thompson, two of the best engravers in London. From 1840 to 1843 he and John Orrin Smith executed some of the best work for the *Illustrated London News*. His success as a wood engraver gave Linton the independence and income to devote his time and

ENGRAVING ON WOOD

N. ORR. SC.

N. ORR,
NO. 52 JOHN STREET,
NEW-YORK,

Informs the public that he continues to carry on the business of Drawing and ENGRAVING ON WOOD, in all its branches. His facilities are such, that he is enabled to execute all orders promptly, and in every style of the art, upon the most reasonable terms.

All kinds of *Book Illustrations, Views of Buildings, Machinery, Landscapes, &c. Portraits, Animals, Societies' Seals, Druggists' Labels, Newspaper Heads, Bill-Heads; Envelope, Tobacco and other Stamps; Illustrations for Printing in Colors, &c., &c.,* Drawn and Engraved in the best style. Orders for *Electrotyping, Stereotyping* and *Lithographic Work* promptly attended to.

Orders by Mail, or Telegraph, may be addressed

N. ORR,
52 JOHN STREET, *New-York City.*

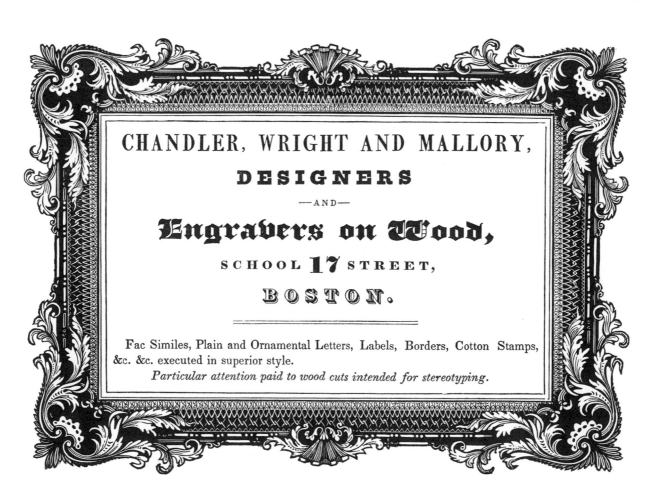

CHANDLER, WRIGHT AND MALLORY,
DESIGNERS
—AND—
Engravers on Wood,
SCHOOL 17 STREET,
BOSTON.

Fac Similes, Plain and Ornamental Letters, Labels, Borders, Cotton Stamps, &c. &c. executed in superior style.
Particular attention paid to wood cuts intended for stereotyping.

money to radical political causes, including Chartism and the nationalist movements in Poland and Italy. His alliance with the artisan class contributed to his beliefs in free speech, universal suffrage, and woman's rights. Linton invested much of his income in journals espousing these beliefs—most notably *The English Republic* and *Cause of the People*. None survived for long, but he did establish himself as a republican activist. Walter Crane, apprenticed to Linton in 1858, captured his master as the radical idealist and idiosyncratic artist:

W. J. Linton was in appearance small of stature, but a very remarkable-looking man. His fair hair, rather fine and thin, fell in natural locks to his shoulders, and he wore a long flowing beard and moustache, then beginning to be tinged with grey. A keen, impulsive-looking, highly sensitive face with kindly blue eyes looked out under the unusually broad brim of a black "wideawake." He wore turn-down collars when the rest of the world mostly turned them up—a coat of a very peculiar cut, having no traditional two buttons at the junction of the skirts at the back, trousers of an antique pattern belonging to the "forties," rather tight at the knees and falling over Wellington boots with small slits at the sides. He had an abundance of nervous energy and moved with a quick, rapid step, coming into the office with a sort of breezy rush, bringing with him always a stimulating sense of vitality. He spoke rapidly in a light-toned voice, frequently punctuated with a curious dry, obstructed sort of laugh. Altogether a kindly, generous, impulsive, and enthusiastic nature, a true socialist at heart, with an ardent love of liberty and with much of the revolutionary feeling of '48 about him.[3]

Between his engraving activity and his political causes, Linton overextended himself. By the 1860s he was exhausted and in debt. His marriage to Eliza Lynn was disastrous, and his children by his previous wife were ill. Contributions to nationalist groups had put him in debt, yet he remained on the fringes of the political events. With little to encourage him in England, he reluctantly left for the United States.

Linton first found employment in New York City as the instructor in wood engraving at the Ladies' School of Design attached to the Cooper Institute. One of his most famous pupils, Caroline Amelia Powell, described his method of teaching:

Mr. W. J. Linton had lately come to this country from England and, from motives of enthusiasm or philanthropy, I don't know which, for he was overrun with work at the time, he offered to teach the class. He was a man who had much personal magnetism, and I remember how enthusiastic we girls were over him. His teaching was most irregular. Sometimes he would come for an hour or an afternoon every day in the week and then we might not see him for a couple of weeks or a month. We worked away more or less in the dark in his absence, but his visits were red-letter occasions, and his talks on engraving and art generally were most interesting and illuminating. He lent the class some of the priceless proofs of cuts in the *Illustrated London News* and other publications, some of them engraved when he was a partner with Orrin Smith, the well-known English engraver . . . They were beautiful proofs, and the most I learned at that time was from a faithful and incessant study of them.[4]

Linton taught intermittently at Cooper Institute for three years. By the time he resigned, he was busily involved with engraving commissions for the illustrated magazines. His skill was appreciated and his artistry respected. He became a member of the Century Club shortly after his arrival, and in 1870 he was elected a member of the National Academy of Design. Secure in his position as the leading wood engraver in America, Linton settled in New Haven in 1870 at his cottage "Appledore." His old interests in politics surfaced briefly, though he was never fully accepted among American liberals. He wrote a satire on Ulysses S. Grant, *The American Odyssey: Adventures of Ulysses* (1876), and a biting critique of corruption in New York City, *The House that Tweed Built* (1871). However, literature interested him more than politics. His own poetry had first appeared in 1865 as *Claribel and Other Poems*; in 1878 he published an anthology of works by American poets, *Poetry of America*. He printed his own poems at his private press in Appledore.

By 1878 Linton seemed to have retired from political activity to lead a quiet life with his daughters in Connecticut. However, he soon involved himself in a new cause, upholding the traditions of wood engraving. Just when Linton felt that American engraving had reached a new level of quality exemplified by the profusely illustrated *Picturesque America*, engraving style changed radically in response to the influence of photography and new artistic trends.

Before 1870 the wood engraver had depended upon an artist to transfer the design to the whitened block before he could engrave. However, around 1870, engravers adapted photographic techniques to transfer the drawing in reverse to a sensitized wood block surface covered with a mixture of silver salts and albumen. The results were dramatic: the artist could work in any size or any medium, the engraver had a minutely detailed design on his block, and the original work of art was preserved. These innovations changed the relationship between the

artist and the engraver. Now any artist could illustrate and demand an exact reproduction because his original work remained intact for comparison. At the same time, the style of the original works of art changed. A younger group of artists trained in Paris and Barbizon returned to the United States during the 1870s with a new painterly technique which they wanted transmitted in reproductions. Public interest in art increased, especially after the Centennial Exhibition in Philadelphia. With the help of photographic technology, a style of engraving evolved to meet the demands of a new art and a new audience.

"The Gilly Boy," engraved by Timothy Cole after James Kelly for the August 1877 issue of *Scribner's Magazine*, marked the appearance of a wood engraving style so revolutionary that it was dubbed the "New School." The technique utilized photography on wood and short white lines and dots in a stippled effect combined with white line cross-hatching. The New School attracted an enthusiastic following centered around Alexander Drake, art editor of *Scribner's*. Under the leadership of Frederick Juengling, Elbridge Kingsley, and Timothy Cole, many wood engravers developed an overly refined style that sought to recreate an exact reproduction of the original. The novelty of the New School was their fidelity to the original work of art, even if their new techniques violated the accepted conventions of wood engraving as line engraving.

William Linton felt the pressure of change, but rather than accepting the new trends, he reacted violently against them. He particularly resented the intrusion of photography. On March 5, 1878, he wrote to fellow engraver A. V. S. Anthony that he was being asked to accept photographs on wood and had replied, "I have answered that nothing will induce me to take a photograph on the wood, and that I can wait." [5] Linton's aversion to photography on wood extended to the New School, whose members depended upon the process and whose very goal seemed to be the duplication of the fine tones of a photographic print. Never one to repress an opinion, Linton championed the cause of traditional wood engraving with the same fervor that had characterized his writings on republicanism.

Linton's answer to the New School, "Art in Engraving on Wood," appeared in the June 1879 issue of the *Atlantic Monthly*. The essay caused an uproar. Linton attacked the reliance upon photography, the use of multiple gravers, facsimile work, and the minute engraving technique that tried to duplicate the brush strokes of the original work of art. He singled out works by Timothy Cole for special criticism as "only models of

microscopic mechanism." As an alternative, he proposed his own view of the engraver as artist and interpreter rather than copyist. For Linton, "every line of an engraving ought to have a meaning, should be cut in the plate or in the block *with design*." Thus each part of the engraving should use an appropriate combination of lines that defined the objects being depicted. Claiming a link with the original style of Bewick, Linton reaffirmed the traditional techniques of a linear style dependent upon conventions of tone expressed by line and rejected facsimile work which imitated steel engraving or photography.

Reactions to the article were heated and prolonged. As the major publisher of engravings by the New School, *Scribner's* was loudest in its condemnation:

It is the conservative old man, who has arrived at the end of his development, and sits petulantly enshrined within his conventional methods, who assumes to be god and arbiter of wood-engraving, passing judgment . . .[6]

Critics of Linton praised the use of photography which allowed the reproduction of any work of art and supported the style of the New School which retained the freshness of the original.

Criticism in unsigned articles was so harsh that Linton felt constrained to retaliate late in 1879 with *Some Practical Hints on Wood-Engraving for the Instruction of Reviewers and the Public*. The small volume was an unabashed polemic. Linton rebuked the reviewers for their ignorance of wood engraving techniques, defended his own experience, and administered lessons in the principles of correct engraving. Once again he affirmed his view of the engraver as artistic interpreter and repeated his criticism of photography as the promoter of a mechanistic style. His chiding was gentle yet pointed, and he never lost his sense of humor. He concluded,

And now, o weary Reader! Farewell! My task—not altogether pleasant—is finished; and I have but to set down *Hints* and patiently await the scalping knives of the Reviewers.[7]

And so the debate raged during 1879 and 1880. From the vantage point of the twentieth century, it is difficult for us to view Timothy Cole's *Modjeska as Juliet* (facing p. 56) as revolutionary or even to distinguish the various engraving techniques. Indeed the entire argument seems futile because we know in retrospect that the New School engravers will be replaced by photoengraving. Yet to the art critics of 1880, the new engravings seemed marvelous because they allowed the large-scale reproduction of works of art with far greater fidelity than had

been been possible before. Excited by photographs, they viewed minuteness as an asset. Nationalism played a role as well. The New School was an American discovery, and their engravings earned praised in Europe. As late as 1891, American wood engravings won medals at the Paris Exposition.

A summation of contemporary views appeared in "A Symposium of Wood Engravers" in *Harper's New Monthly Magazine* for February, 1880. A. V. S. Anthony was in the minority with his support of William Linton. The other engravers were members of the New School—Timothy Cole, John Parke Davis, Frederick Juengling, Richard Mueller, John Tinkney, and Henry Wolf. All praised Linton for his part in improving wood engraving, but they consistently criticized his engraving style which often hid the intention of the original work of art. Juengling, the most vitriolic, summed up the different intentions of the new style:

It proposes to engrave anything, and to engrave it realistically. It does not idealize at all. What it seeks is a perfect reproduction of the original.[8]

Although he did not participate in the "Symposium," William Linton did not remain quiet for long. In fact, the dispute with the New School prompted a succession of publications on wood engraving. While writing *Hints*, he began to assemble material for a history of American wood engraving. Because of his reputation and his writing experience, he was the logical person to undertake such a project. Judging from letters dated October to December 1879 (now in Yale University's Beinecke Library), Linton asked engravers to name their best works and submit specimens for his history, a standard nineteenth practice for authors. Respect for Linton was so great that even Timothy Cole replied. Some of the older men supplied details about the early days of the craft which Linton incorporated. The final book was a mixture of replies, memories, opinions, which created a highly personal interpretation of the rise and fall of American wood engraving.

The History of Wood-Engraving in America first appeared in 1880 as a series of eight articles in *The American Art Review*, a new journal edited by S. R. Koehler to promote the fine arts, including prints. Though called a history, Linton's essay was actually a summation of his critical attitudes and æsthetic beliefs. Because of his early experiences, the American development was related to English styles. In the first three chapters Linton recounted the history of the early phases of wood engraving through chronologically arranged biographies of the early engravers, many of whom he rescued from oblivion. Chapter IV covered the development of the illustrated magazines. In the following four chapters, Linton shifted increasingly from historical narrative to criticism. Chapter VI was devoted to Harpers and Scribners with detailed evaluations of individual illustrations. He asserted his familiar view that the New School was "an endeavor to excessive fineness, to the sacrifice of what is most essential in engraving, intelligence." Chapter VII covered Timothy Cole, Frederick Juengling, and Gustav Kruell in detail. Kruell was praised for his portraits, Cole received constructive criticism, but Juengling was harshly criticized, perhaps because of his opinions in the "Symposium." In Chapter VIII, the final article in the original series, Linton concluded that the members of the New School were talented, but misdirected by modern painters, critics, and publishers. His interpretations were obviously biased, as Linton himself admitted,

I have not written merely to supply a dry chronicle of the doings of American wood-engravers; I have written in praise or blame as seemed just to me, distinctly from a desire to help the advance of wood-engraving in America.[9]

Forever the artisan and reformer of 1848, he still hoped to teach the public and the engravers the value of wood engraving as an art form. Linton did not claim objectivity for his history which he described as a "Preliminary Study of History as part-preparation for some completer volume."

Estes and Lauriat, publishers of *The American Art Review*, re-issued *The History of Wood-Engraving in America* as a separate volume in 1882. The edition was limited to 1026 numbered and lettered copies, each signed by Linton. It was a fancy book aimed at the collector with blank pages in the back where other engravings could be mounted. The text and illustrations were the same as those in the original magazine articles, except for the addition of Chapter IX, a more cogent recapitulation of Linton's attitudes toward engraving and the New School. He again focused upon Harper's and Scribner's magazines, and particularly condemned the effect of photography on the art of wood engraving.

Critical reaction to the *History* was mixed. *The Saturday Review* (London) called it a "work of sterling merit," and *The Nation* commented, "Mr. W. J. Linton could hardly have rendered his country a greater service than by writing his History . . . a labor of love." The *Atlantic Monthly* praised the accumulation of historical facts, and *Harper's New Monthly Magazine* was surprisingly complimentary, stating, "It abounds in matter of historical interest, and is throughout

"The Wissahickon—Summer," from Strahan, *A Century After* (1875)

suggestive and instructive." Others, like *The Century* (formerly *Scribner's*) appreciated the historical sections but complained about Linton's evaluation of the New School. *The Critic* thought the series had "for their only visible purpose the raising of a row by saying hard things of as many people as possible." *The American Architect and Building News* felt that Linton's opinions were based on "prejudice, willful narrowness, and lifelong habits of seeing and feeling" and concluded, "The history of wood-engraving in America remains to be written by someone who shall really be a historian, and not a partisan pamphleteer." Others praised the reproductions, the usefulness as a guide for collectors, and lamented the lack of an index. Yet most critics agree that the work made a significant contribution, and in general echoed *The Saturday Review*:

In conclusion we can safely say that, although we differ greatly from Mr. Linton's judgment in many particulars, we believe that this work deserves to find a place in every art library, and that it will be of the greatest use to all students of wood engraving.

The History remained popular and was reissued in 1889 as part of *American Art and American Art Collections*. The final critical chapter was omitted, which seems appropriate since the two volume set was a conglomeration of wood engravings and half tones which Linton would have deplored.

After the turmoil of the early 1880s, Linton settled into a quiet routine at Appledore Farm. He devoted his time to the press which he had purchased in 1879 to proof of his own engravings. He acquired some type and learned to set it. Eventually he was able to execute all of the steps involved in book production himself, from writing and engraving to printing and binding. Over half of the thirty-six dated imprints from the press were prepared when Linton was over seventy-five years old.[10] The most impressive work from the press was *The Masters of Wood-engraving*, for which Linton prepared three copies of 229 folio pages with plates pasted in. The folio was published commercially in 1885-86. In it Linton outlined the history of the wood cut and the wood engraving from the Middle Ages to the present, culminating twenty years of research in the British Museum.

In addition to his private press work, Linton occasionally publicized his views on wood engraving. In 1884 he produced *Wood-Engraving, A Manual of Instruction* in the tradition of self-instructional manuals which had been popular since the 1870s. The book began with the usual description of tools and techniques for the beginner, but Linton had an underlying motive in his manual. His goal was the creation of a school of competent artist-engravers who would follow his guidelines and restore the art of wood engraving to the originality and expressiveness of 1790-1835. Once again photography was the scapegoat and the New School was called "the perfection of the imbecile."[11]

By 1890, the interest in wood engraving had declined because the craft itself no longer seemed necessary once half tones and photo engravings could be produced more cheaply. Linton predicted the problem in his address to the Applied Art Section of the Society for the Encouragement of Arts, Manufactures, & Commerce, delivered in the Adelphi, London, on March 25th, 1890. He said that *Harper's* and *The Century* had

generally clever and pleasing pictures, well designed, effective, and nearly as good as photographs. Pure photographs, if be had, would however well replace them and we would then escape the infliction of linear ugliness and be no longer annoyed with the pretense of engraving.[12]

Linton's analysis was accurate. The efforts of the New School, so ardently espoused by its proponents, led only to their decline. Kingsley, Cole, Kruell, and others formed the Society of American Wood-Engravers and exhibited across the country, but their attempts at art engraving represented the final gasps of the movement. Not even the artists themselves supported the New School engravers because they preferred a poor photographic reproduction of their art to an interpretive wood engraving, however accurate. Issued in huge editions, wood engravings lacked the preciousness of etchings and metal engravings. Publishers preferred the cheaper mechanical processes, and few of the reading public cared about subtle differences. Thus by the 1890s, many wood engravers were out of work or merely doing detail work for halftone plates. Wood engraving continued into the twentieth century as a commercial method for illustrating mail order catalogues.

During the 1920s and 1930s, artists revived woodcuts and wood engraving as a direct printmaking process rather than a reproductive craft. They utilized the white line of Bewick, but eliminated the middle gradations of tone and tint which were the pride of the late nineteenth century. Artists like Rudolph Ruizicka and Howard McCormick capitalized on the strengths of the relief process—high contrasts of light and dark and the clear definition of forms. Many of their goals resembled those of Linton: the rejection of photography, the emphasis on the engraver as artist, the interpretive use of the burin to achieve

THE HISTORY

OF

WOOD-ENGRAVING IN AMERICA

THE HISTORY

OF

WOOD–ENGRAVING IN AMERICA.

CHAPTER I.

HAT I am here attempting is a history of Engraving on Wood in America, not a dictionary of American engravers. For the first I think I have found enough to interest my readers; albeit of printed record there is nothing of any worth except Lossing's *Memorial of Dr. Anderson*, some half-dozen lines concerning three men (Anderson, Dearborn, and Hartwell) in Drake's *Biographical Dictionary*, and about as scanty information in Dunlap's *Arts of Design in the United States*. What I have gathered else has been from correspondence or conversation with the older men yet living, impartially collating the same; and from careful examination of whatever I could obtain access to of their and of the later works. Of five hundred engravers (more or less) of the present day what could I write? Even their names cannot be collected, nor any recollection had of many who are dead and gone. To attempt biographical notices had been a vain task. So I have only cared, except in two exceptional cases, for a review of the rise and progress of the art, with such instances as I could select of the best and most representative character. I have endeavored to be fair in my judgments; and if sometimes I have omitted names or lost sight of works that ought to have been mentioned and noticed, it has been from sheer oversight, not with intention. I have here to thank both engravers and publishers for the facilities they have afforded me in my work. So much as preface.

At the outset I may glance at a report, not without show of probability, that Franklin "cut the ornaments for his *Poor Richard's Almanac* in this way"; that is, on metal, in the manner of a wood-cut, for surface printing. He may have done so. Blake the painter did such metal plates as well as wood-cuts. The process is the same. Nevertheless, it is to Dr. Alexander Anderson that we may rightly ascribe the honor of being the first engraver on wood in America. Dunlap, in his *Arts of Design*, speaks of an eccentric genius, one John Roberts, a Scotchman,

of whom Anderson might have learned the art. I believe this also to be only rumor, based on the fact of Anderson's having been acquainted with the man, a miniature-painter and copper-engraver, and having engraved on copper with and for him. The first knowledge of box-wood being used for engraving may perhaps have been gained from Roberts, the date of his arrival in this country being that of Anderson's first attempts upon wood. It would not subtract from Anderson's merit. Lossing does not intimate even the likelihood of such a beginning. To Lossing I am mainly indebted for the biography of Anderson. Nearly all I can give concerning him, except some dates of books, and of course my own criticisms (only applied to work I have seen), I have learned from his *Memorial*, prepared for the Historical Society of New York, read to the members on the 5th of October, 1870, and printed for the Society in 1872, — prepared from materials gathered from Dr. Anderson himself, from his daughter, his grandson, and other friends.

ALEXANDER ANDERSON, AGED 92.

DRAWN BY AUGUST WILL. ENGRAVED BY ELIAS J. WHITNEY FOR THE "CHILD'S PAPER," 1867, PUBLISHED BY THE AMERICAN TRACT SOCIETY.

ALEXANDER ANDERSON was born on the 21st of April, 1775, two days after the battle of Lexington, in the same year that Bewick (then twenty-two years of age) received the premium of the Society of Arts, in London, for his engraving of *The Huntsman and Hound*, afterwards printed in an edition of Gay's *Fables*. Anderson's father was a printer, a Scotchman, but a

stanch supporter of the Colonial side, and a sufferer for the cause. Young Anderson's taste for art he himself attributed to his mother, who was in the habit of drawing for his amusement when he was a child. Prints also came before him (Hogarth's and others) through his father's business. " These prints," he writes in one of his letters, " determined my destiny." Such determination, one can see, was also helped by his getting hold of some type-ornaments, which gave him a notion of at least one kind of print-production.

At school he amused himself by copying engravings. Then, reading in Rees' *Cyclopædia* of the process employed, he got a silversmith to roll him out some copper cents; and with a graver made of the back-spring of a pocket-knife, ground to a point, started himself as amateur engraver on copper. He was twelve years old when he began; and proud enough, there is no doubt, when he had scratched out a head of Paul Jones and — he tells of it himself in a brief autobiographical paper — " got an impression with red oil-paint in a rude rolling-press " of his own constructing, — the same used by him two or three years later in taking impressions of his engraving of a head of Franklin. Afterwards a blacksmith made him some tools; and he engraved ships and houses and the like, for newspapers, of course in relief. In this way he soon earned money, only one other person being so engaged in New York.

On leaving school, his father not approving of his choice of engraving as a life-business, he was placed to study medicine under Dr. Joseph Young, going to him on the 1st of May, 1789, the day after the inauguration of Washington as first President of the United States. With Dr. Young he remained five years, occupying his leisure hours with engraving, of the most miscellaneous character, — anything from a dog-collar or card to a book frontispiece. So that before he had eighteen years of age he was employed by all the printers and publishers in New York, occasionally by others also, in New Jersey, in Philadelphia, and even as far as Charleston. At first his artist work was only on copper or type-metal, — on the latter I suppose in wood fashion, to be printed from the surface. But in 1793, being then eighteen, he had sight of certain works by Bewick (then claiming some attention in England, and of course the echo of his notoriety reaching here), learned what material he used (that perhaps from John Roberts), and, from the cuts themselves, of Bewick's method. He made trial of box wood, and changed his course.

Some discrepancy occurs here in Lossing's dates. He says (page 32) that Anderson was ignorant of the use of box-wood until " early in 1794," when he was favored with a sight of Bewick's *Birds* and *Quadrupeds*. In the same page he writes: " The first mention of its use for gain in his Diary is under the date of the 25th of June, 1793, when he engraved a tobacco-stamp. *A few days afterward* he agreed to engrave *on wood* one hundred geometrical figures for S. Campbell, a New York bookseller, for fifty cents each, Campbell finding the wood. This was procured from Ruthven, a maker of carpenter's tools, who at first charged three cents apiece for the blocks, but finally asked four cents." To properly face the wood was a new, and no doubt a difficult, kind of work for him. " Campbell," Lossing tells us, " was not well pleased, but concluded he must give him that. It was *more than a year after that* before Anderson ventured to engrave elaborate pictures on the wood." The first of these were for Durell, the date of which Lossing gives as 1794, showing that the previous statement of 1794 as the time of his first acquaintance with Bewick and box-wood must be wrong, — most likely a misprint. Bewick's *Quadrupeds*, however, Anderson himself tells us in his Diary (this quoted too by Lossing) he first saw on the 17th of August, 1795. The book first seen may have been *The Looking-Glass for the Mind*, an earlier work of Bewick.

In 1794 then, at the age of nineteen, having given a year to experiments on the wood, he was actually, for William Durell, a New York publisher, copying these *Looking-Glass* cuts still upon type metal, when, the work about one third done, he felt satisfied that he could do them better upon wood; and in September of that year attempted one of them in the new material. Here are extracts from his Diary: —

FROM THE "LOOKING-GLASS OF THE MIND."

"*Sept.* 24. — This morning I was quite discouraged on seeing a crack in the box-wood. Employed as usual at the Doctor's. Came home to dinner, glued the wood, and began again with fresh hopes of producing a good wood-engraving."

"*Sept.* 26. — This morning rose at five o'clock. Took a little walk. Engraved. Employed during the chief part of the forenoon in taking out medicine. Came home after dinner and finished the wooden cut. Was pretty well satisfied with the impression, and so was Durell. Desired the turner to prepare the other twenty-four."

The remainder of the book was done on wood. [In 1800 a new edition, brought out by Longworth, was altogether on wood.] Thenceforth type-metal was discarded, and Anderson became an ENGRAVER ON WOOD.

In 1795 he was licensed to practise medicine. When, soon after, the yellow-fever prevailed in New York, he was appointed by the health commissioners of the city as resident physician at Bellevue Hospital, three miles out of town: his salary twenty shillings a day. He was there three months, from August to November, 1795, for part of the time the only physician, at one period with from thirty to forty patients under his care. Notwithstanding this heavy charge, he found time for his favorite engraving. Yet not neglecting his hospital duty, as is sufficiently proved by the offer to him shortly afterwards of the post of Physician to the New York Dispensary, which his passion for art forbade his accepting. In the next year he received his diploma as Doctor of Medicine. He was now a physician, a designer and engraver (on both wood and copper), and (having taken a store for the purpose) a bookseller and publisher of small illustrated works. The bookselling, not bringing profit, had to be given up. Not so the engraving, which still alternated with his practice as a physician, a practice successfully continued by him, though against the grain, — for he was not only conscientious, but "morbidly sensitive," — until 1798. In 1798 the yellow-fever again visited New York. Anderson's infant son died of it in July; and in September his wife, his father and mother, his brother, mother-in-law, and a sister-in-law, had all fallen victims. Utterly desolate, one can understand how he had no heart left for the active medical life. He voyaged next year to the West Indies, and two or three months spent with an uncle, who was "King's botanist" in the island of St. Vincent, stirred in him some care for botany, — a consolation in his sorrow; but we cannot wonder that henceforth he preferred the quiet seclusion of an engraver's work. The early delight became his sole occupation and his solace. Seventy years remained for him. He married again, a sister of his wife. But it is time I turned from the personal history of the man (well worthy of more amplification, for he was a man of extraordinary character and talent, at once physician, engraver, designer, botanist, musician, and verse-maker) to the special subject of my writing, a consideration of the engravings produced by him.

I may omit, beyond mention of a few, those executed by him in copper, as well as those upon type-metal. In 1793 he had not only acquaintance, but employment, with John Roberts, before spoken of; helping him in his work and also engraving plates for him, among them a portrait of Francis I. as frontispiece to Robertson's *Charles the Fifth*, published in New York in 1800. Numerous other plates he engraved for various publications: his last important works of the kind in 1812, a copy of Holbein's *Last Supper*, six inches by eight, to illustrate a quarto Bible; and some allegorical designs of his own, the *Wheel of Fortune* and the *Twelve Stages of Human Life—from the Cradle to the Grave*. I pass now to his engravings on wood, to which after 1812 he chiefly devoted himself.

His first, as before said, were those for the *Looking-Glass of the Mind*, done for Durell, — poor cuts certainly in manipulation, but not without an artist's feeling; his originals were poor.

Durell, writes Lossing, "became an extensive reprinter of English works, small and great, from toy-books to a folio edition of *Josephus* and more than a hundred volumes of *English Classics*. He employed Anderson to reproduce the pictures in these works," (seldom, I imagine, more than a single frontispiece, — the custom then,) " and they were done with great skill considering his opportunities." For Hugh Gaine, the eminent journalist during the Revolution, he engraved "on type-metal" illustrations of the *Pilgrim's Progress ;* for Brewer, cuts for *Tom Thumb's Folio ;* for Harrison, pictures for a book of *Fables ;* for Babcock, of Hartford, fifteen cuts for fifty shillings ; for Reid, Campbell, and Wood, portraits and cuts for their several editions of Dilworth's *Spelling Book ;* for Philip Freneau, the poet, cuts for a *Primer ;* and in 1795 began engraving the cuts for an edition of Webster's *Spelling Book* for Bunce & Co.

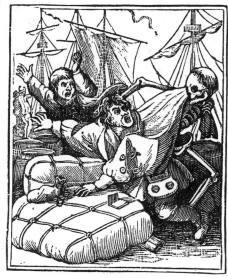

(afterwards published by Cooledge). So Lossing, from whose words it would seem that all these works except the *Pilgrim's Progress* were engraved on wood. I incline, however, to think that some, if not all but the Webster, were early works, and on metal. There is no finding out without sight of the metal or wood blocks themselves. After all it matters not: his type-metal work, speaking *Hibernice*, was only wood-engraving on metal.

Of some later works I can speak with more certainty. In 1796 he drew and engraved his great cut of the human skeleton, a cut three feet high, enlarged from Albinus's *Anatomy*. Of this cut, which he was justly proud of, (he showed it to me the only time I saw him, not long before his death,) but two or three impressions were ever printed, the block being broken by the pressure. It was indeed a remarkable work, especially for that time. He also drew and engraved, on wood and copper, illustrations for an early edition of Irving's and Paulding's *Salmagundi ;* copied fifty cuts done for *Emblems of Mortality* (Holbein's *Dance of Death*) by Thomas and John Bewick, published in 1810 by John Babcock of Hartford, Conn., and republished by Babcock & Co., Charleston, and S. Babcock, New Haven, in 1846, on which occasion "three of the cuts, representing Adam and Eve in various situations, it was thought advisable to omit." The last cut was also omitted, "being apparently obscure in its design to an American reader." In 1802, for David Longworth, he undertook the reproduction of Bewick's *Quadrupeds*, three hundred cuts.

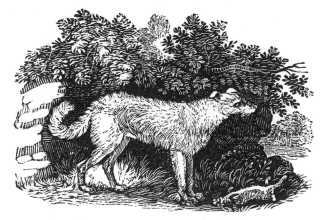

FROM BEWICK'S " QUADRUPEDS," AS RE-ENGRAVED BY ANDERSON.

I have not been able to obtain a sight of Anderson's book ; the one copy I heard of in the Society Library, New York, having been taken away and not returned. But I have seen the cuts, the electrotype plates having fallen into the hands of another publisher, T. W. Strong, who made use of them, with the Bewick letter-press also, for a series of children's toy-books. Comparing them with the English originals, I find that they are all directly copied from Bewick,

FROM THE SHAKSPERE. — AFTER THOMPSON.

appearing in the Anderson edition reversed. No doubt this was done, transfer of prints not being then understood, to facilitate the work of the draughtsman, though thereby the engraver had to follow back-handed the lines of his master. Considering the little practice *on wood* which Anderson had then had, they are wonderfully close copies: varying in excellence, but all very faithful in drawing and good in engraving; tamer certainly than the originals, as must be expected, and much inferior to them, yet showing a real artistic perception of their best qualities. About this time also he may have engraved for Longworth the *Fables of Flora* : ·head-vignettes on copper, tail-pieces on wood. He speaks too (in the very brief sketch of his own life, written by him in 1848, in the seventy-third year of his age) of Mr. Samuel Wood as one of his "most constant employers," — I suppose at about this period of 1800, or later. Wood was still in business twenty years afterwards. "I did," says Anderson, "an infinity of cuts for his excellent set of small books."

In 1812 he engraved a dozen cuts for a Shakspere for Monroe & Francis: copies from cuts by John Thompson, after Thurston's designs. They are noticeable as the chief of his very few departures from the style of his favorite Bewick. Yet not altogether a departure. Thompson's work was, I have no doubt, in the usual manner of Thurston, a rich crossed black line; Anderson, keeping the general order of lines, has cut out the crossings, doing the work rather in white line, though the feeling and drawing and much of the character of the original engraving are preserved. He copied in similar style a series of the *Seven Ages*, also by Thompson. About 1818 he appears at his best. That date is given by Lossing to four large engravings after the German artist, Ridinger, engravings (Lossing says) 12½ by 9½ inches, illus-

trating the *Four Seasons*. Lossing adds: "He also engraved on a little smaller scale the same subject from paintings by Teniers." After a long search I came to the conclusion, in which a conversation with Dr. Lewis (the grandson) has since confirmed me, that Lossing's statement is incorrect. Only two, instead of eight subjects, were engraved by him, copied, it would seem, from copper plates, only using white line instead of black: one by Ridinger, *Returning from the Boar-Hunt*, its measurement slightly different from that given by Lossing; the other after Teniers, *Waterfowl*, a square subject 11½ by 8¾ inches. I suppose he may have executed these as a trial of strength, or as a speculation, with hope of having the series taken up by some publisher; and that, disappointed in this hope, he did not care to complete the sets. The Ridinger (herewith given) speaks for itself. No more vigorous piece of pure white line work has been done outside of the Bewick circle. By pure white line I mean a line drawn with

FROM THE "FABLES OF PILPAY."

meaning by the graver. The Teniers, a reedy lake with wild ducks in the water and others flying, and some rabbits under trees on a bank, is scarcely if at all inferior to the other. The date of 1818 is engraved on this.

I find no date for the *Fables of Pilpay* (lately republished by Hurd and Houghton), some fifty or more small cuts following the designs of an English edition, but "better engraved," says Lossing. They are of Anderson's best work, better in command of line and finer than his ordinary work; and may perhaps be placed about this time, but I only hazard a guess. Somewhere at this date also I would look for a *Paul and Virginia*, of which I have only seen four or five cuts, copies of course, but with delicacy of line and touch not usual with him. For the twenty years following the two Ridinger and Teniers cuts I can find nothing certain. Lossing, not very orderly or regular in his list of works, has that width of gap. I am disposed, however, to place here some illustrations to *Peter Parley's Magazine* and other publications of the same author, and a series of large and rather coarse Bible cuts. (See next page.) There seems to have

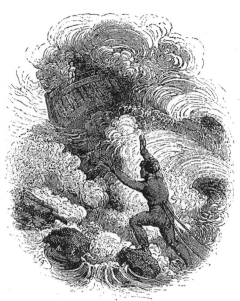

FROM "PAUL AND VIRGINIA."

been no encouragement for such work as he proved himself capable of when he did the Ridinger and Teniers. The next noticeable work I find is in O'Reilly's *Sketches of Rochester*, 1838, which contains cuts by him, and Hall, and J. W. Orr, generally street views or buildings, very stiff and formal; Anderson's the best, with an exactness and evenness of line hardly to be expected after his earlier free-handedness. Of the same character, and about the same date, or it may be somewhat ear-

lier, is a series of larger cuts of old buildings in the city of New York, done for the *New York Mirror*. He engraved also initial letters for Mrs. Balmanno's *Pen and Pencil;* the illustrations to Downing's *Landscape Gar-*

FROM "SKETCHES OF ROCHESTER."

dening, 1841; and some forty designs by T. H. Matteson for a *Shakspere* published by Cooledge & Brother in 1853. Later in life his handiwork appeared in Bentley's *Spelling Book;* and yet later in a series of Revolutionary portraits. For many years he engraved for the American Tract Society small cuts, easily distinguished, to be found in their early publications. For many years also he was in the habit of engraving a larger and coarser class of work, chiefly illustrations of the life of the B. Virgin Mary, for Spanish printers in the West Indies, Mexico, and South America. Of these and of the Matteson series (neither worthy of his best powers) sufficient specimens are given in the Lossing *Memorial*. Some of his latest works, if not his last, were from drawings by H. L. Stephens, done for T. W. Strong. He was at work for his own amusement, I believe, to within a few days of his death. He died on the 17th of January, 1870, in the ninety-fifth year of his age.

Considering the vast amount of work accomplished by him, the many thousands of cuts he engraved, it is surprising how little can be met with even after a very careful and persistent search. Of the many cuts in Mr. Lossing's earnestly admiring *Memorial* there are not five that

would establish Anderson's pretension to be even a good engraver. In the collection privately printed by Mr. Moreau, 1872, " one hundred and fifty engravings executed after his ninetieth year," we of course do not look for anything of much importance. The best there is a copy from a tail-piece from Bewick (not by Bewick's own hand, but Clennell's), which I have no hesitation in attributing to much earlier years. Some others also seem to me very dubiously dated. Most are very small, many mere inch-square trifles done for his own pleasure, evidences that he retained his artistic perceptions, with some

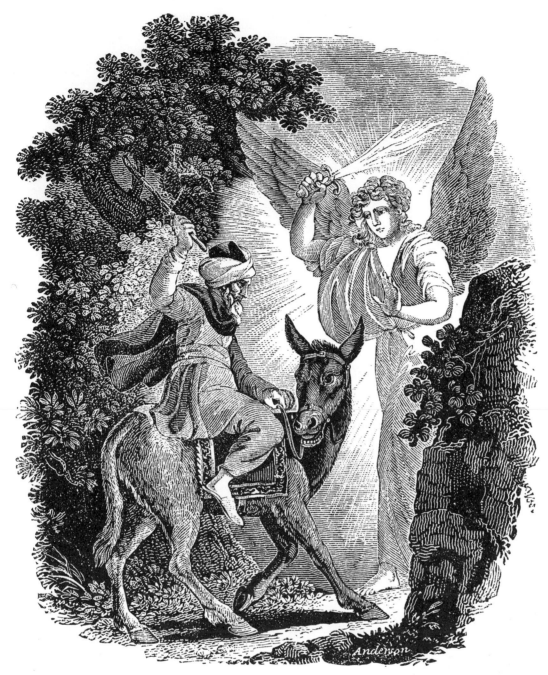

BALAAM AND THE ANGEL.

very notable amount of his old manual skill also, — proofs of the man's indomitable perseverance and unfailing love for his occupation; but in themselves, as engravings, without thought of him and his age, not very remarkable. One little cut (here poorly reproduced) shows an exceptional minuteness and delicacy. But there is not enough in any of them to command much admiration simply as graver-work. And the same may be not unfairly said even of the work of his prime. The copies of Bewick (the staple of his best work) are wonderful, having regard to the

FROM THE MOREAU COLLECTION.

circumstances in which they were produced; but no appreciator of Bewick could speak of them as worthy of comparison with the originals. They are curiously good copies, valuable pioneer work, helps toward better. After these early things there is little improvement. I find only the two large cuts standing out as marks of a capacity which had not corresponding development. Such cuts as are given in the *Memorial*, not copies, but altogether his own work, (allowing that there may not have been much opportunity for choice,) bear out this judgment. The *Lear* and *Twelfth Night*, from Matteson's drawings, page 38, where

the line is his own, the *Holy Family*, page 65, the *Embargo*, page 70, are but common cuts. Probably his life through he was working for low prices, and there was neither demand nor appreciation for better work. None the less, however excused, he has to suffer the reproach of inferiority. It is an ungrateful task to pick out faults. It is part, though, of the critic's duty. He has to distinguish — let it be generously, yet truly — between the good and the bad, the better and

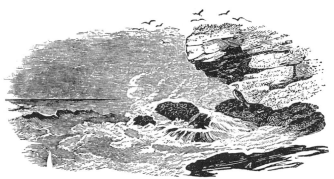

TAIL-PIECE. — AFTER CLENNEL.

the worse. In truth, except within the limitation of hindering circumstances entitling him to credit for overcoming so much of obstacle, a close study of all of Dr. Anderson's engraving on wood that I have been able to get sight of fails to draw from me a recognition of his special genius as *an engraver*. Had his work been original, like Bewick's, it had, indeed, been great; but, practised as he was on metal, and with Bewick's work before him, one thinks that, with his undoubted artistic feeling, conscientious study, and constant industry, he should have done more. He never equalled his master, nor have I seen anything of his (except the two large cuts) to compare with the work of Bewick's pupils, Nesbit, Clennell, Hole, Hughes, or Harvey. It must

be owned, however, that we never see him at his best. Bad printing is not favorable to an engraver's reputation, nor does good printing avail on worn blocks. The only specimens we are able to give are but phototypes from ill-printed impressions. After all deductions, his is the honor of being the first wood-engraver in America.

For the rest, so remarkable was the man, so worthy of honor for himself as well as for the variety of his knowledges and doings, that he can well afford to be rated lower in this one of

AFTER BEWICK.

his endeavors, can well submit to be considered under this one aspect of *engraver on wood* as first in time only, not in the average of the work he did. Of his faculty as an engraver on copper and as a designer, it has not been within my province to speak. The esteem of his artist contemporaries was shown by his election, in May, 1843, as an honorary member of the National Academy of Design. He had also been a member of the earlier New York Academy of the Fine Arts.

CHAPTER II

HE beginning of engraving made by Anderson others followed. He himself had only four pupils: Garret Lansing, — I quote from Lossing, — "of the old Lansing family of Albany; William Morgan, of New York; John H. Hall, of Albany; and his (own) daughter Ann, who became the wife of Andrew Maverick, a copperplate-engraver. LANSING received instructions in the year 1804, and was the second wood-engraver in America." He returned to Albany, and began business, depending for employment on Anderson, who sent him box-wood and drawings "by the Albany sloop." In 1806, (still from Lossing,) "he was married to a young lady of wealth, as fortunes were estimated in those days, and went to Boston for the purpose of practising his art there," but was so little encouraged that he went back, and afterwards made his home in New York. He was "skilful in the engraving of machinery." I cannot recover anything of his work. MORGAN "engraved well," but abandoned the graver for the pencil. Though spoken of as Anderson's favorite draughtsman, he seems to have made no particular impress. Hall I shall have to speak of later.

NATHANIEL DEARBORN, a stationer and printer and engraver on copper, whose card in 1814 bore the words, "Engraver on Wood, School St., Boston," is said to have brought wood-engraving to Boston in 1811. Drake calls him "one of the first" engravers. He was the publisher, so late as 1848, of *Boston Notions*, projected in 1814 and part-published in 1817, containing (says Lossing) his earlier engravings. I believe, however, that he was only a letter-engraver; and that the first engraver on wood in Boston, entitled to that distinction, was Abel Bowen.

ABEL BOWEN (Abel C. according to Lossing, only Abel on books published by him, A. Bowen on his cuts), was born at Greenbush, opposite Albany, New York; and, after serving an apprenticeship at Hudson, began business for himself as a printer in Boston. He was also an engraver on copper, where or of whom learning the art I do not find, — probably also at Hudson. No doubt his work on copper led to relief-work on metal (in the manner of wood-engraving) for surface-printing, and thence to engraving on wood, which he began to practise in 1812, I believe self-taught. Lossing speaks of "his style" as "more like the English engravings of our day than like Bewick's"; but this must be taken to mean only that he copied later works as well as Bewick's. Style can hardly be called his: he was the faithful imitator of the various works which in the course of his business he had to copy. I have before me some cuts for an American edition of the *Young Lady's Book* (published by him in 1830), containing over seven hundred engravings (including small initial letters), copies of cuts by Thompson, S. Williams, Bonner, and others. Three of them, after those three very different engravers (that after Thompson here given — unfortunately only from a process reproduction, which fails

to render its delicacy), are very remarkable for their fidelity to the originals. The distinguishing manner of each engraver is so exactly preserved that I was with difficulty convinced the cuts were not done from transfers. Besides this *Young Lady's Book*, his most important work in engraving, he published several books: the *Naval Monument*, in 1816, copyrighted in 1815, with one hundred and twenty-five engravings, one by Anderson, the rest Bowen's own, the book also compiled by him; *A Topographical and Historical Description of Boston*, in 1817, with cuts from drawings by S. Dearborn; a *History of Boston*, with engravings on wood and metal; also Bowen's *Picture of Boston*, with two copperplates, beside wood-cuts, by himself, and other copperplates by Joseph Andrews, in 1829. The work through all these is very much of the same character as Dr. Anderson's earliest cuts.

In 1810, WILLIAM MASON, a native of Connecticut, introduced the art to Philadelphia. He was soon followed by his pupil, Gilbert. Later I come upon the names of Fairchild, in Hartford; Horton, in Baltimore; Barber, in New Haven. Of the last, still living in New Haven, in his eighty-third year, I am able to give some brief notice.

JOHN W. BARBER was born at Windsor, Conn., on the 2d of February, 1798. When he was but thirteen years old, the death of his father left him as sole support of his family. He worked on their small farm, learned to hoe and dig and plough, to cut wood, milk a cow, drive a yoke of cattle, also to "turn up brick in a brick-yard, and to pound clothes for the women on washing-days." Before then, a studious, thoughtful boy, fascinated by the

AFTER THOMPSON. — BY A. BOWEN.
From the "Young Lady's Book."

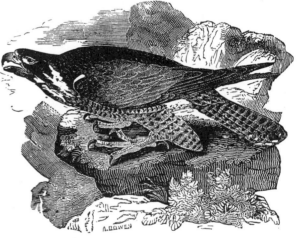

AFTER BEWICK. — BY A. BOWEN.

pictures in his books, he had begun to imitate them, — "at seven years of age" trying his hand on a pen-and-ink design for Nelson's victory at Trafalgar. At East Windsor the then best letter-engraver in the United States, Mr. Abner Reid, had a bank-note engraving establishment, and to him the young farmer was apprenticed. Philadelphian Mason, also an apprentice of Reid's, must have been there not long before him. In 1823, he came to New Haven and took an office for engraving. Since then he has been at once draughtsman, engraver, author, editor, and publisher. The first of his publications was a series of wood-cuts on a half-sheet: *Bunyan's Pilgrim's Progress exhibited in a Metamorphosis, or a Transformation of Pictures*. Of his many works the principal have been topographical and historical: *History and Antiquities of New Haven; History of New England; European Historical Collections; Collections of Connecticut;* etc. For the Connecticut history, published in 1837, he travelled in a one-horse wagon, collecting materials and making sketches for the two hundred illustrations to the book. From 1856 to 1861 he was preparing *The Past and Present of the United States*, for which he engraved some four hundred cuts from original drawings by himself. I may speak in this place even of his latest works, for they are all of the style and character of the earliest days, without change or improvement. His chief ambition has been, not success in engraving, but to "preach the Gospel

by means of pictures ": toward which end he has
issued, in addition to his historical, various emble-
matic books, since combined in a thick octavo
volume known as the *Bible Looking-Glass*, of
which it must be owned that the pious intention
asks more praise than either the designs or the
engraving. The cut here given, from *Easy Lessons
in Reading*, New Haven, 1824, is a fair sample of
his work. He could not be neglected in a history
of American engraving.

FROM "EASY LESSONS IN READING."—BY BARBER.

JOSEPH ALEXANDER ADAMS, next of impor-
tance in order of time, stands out also as first in
talent in our historical course. Nearly all I know of him (self-taught like Anderson and Bowen)
I have learned either from his letters to me or in recent conversations with him. He had been
so entirely forgotten that I had difficulty in finding that he was yet alive: his name on the books
of the National Academy of Design, of which he became an associate in 1841, being only re-
tained because the Academy had not been notified of his death. He was born at New German-
town, Hunterdon County, New Jersey, in 1803; and was apprenticed at an early age to the
printing business, having successively three masters, the first failing and the second giving up
business. At the age of twenty-one he went to New York, and for three weeks worked there
as a journeyman printer. During his apprenticeship he first tried his hand at engraving. A
cut of a boot was wanted for some shoemaker's newspaper advertisement, and the printer's fore-
man attempted to engrave one. Engravers were scarce in those days: only three, I think, in
New York, — Anderson and his pupils, Lansing and Morgan. The foreman unsuccessful, young
Adams made attempt, and so far succeeded as to satisfy the immediate need and to stimulate
himself to further essays, though without any instruction, and knowing absolutely nothing of the
ordinary process of engraving. In his own words, he proceeded as follows: — " I intensely
blackened the block with India ink, then marked the outlines of the subject with a point, and
cut away at it. I had not then even heard of finished drawings being made on the wood. I
worked in this manner for about six months. One day Mr. Samuel Wood, a publisher of
juvenile books, advised me to go to see Dr. Anderson. I told him I was afraid he might think
I wanted to steal his art; but he replied that the Doctor was not a man of that kind. I mus-
tered courage, and, after walking several times to and fro in front of his house, ventured to
knock at the door, entered, and saw him for the first time. I found him very pleasant and
communicative. He showed me the block he was then working on; and, to my astonishment,
I found the whole design was neatly washed on the block, complete, with India ink alone. This
was entirely a new idea to me. I went home, and the next day adopted the same plan, which
I pursued ever after. The Doctor was very kind to me; gave me many hints, such as lowering
parts of the block after the manner of Bewick, so as to print faintly. He also sent me customers
occasionally. He laid before me several of Bewick's works which I had never heard of before,
and also showed me many other specimens of cuts done by English and old German artists."
The cuts done in those days were few, the principal for toy-books and similar juvenile works,
published by Samuel Wood, Mahlon Day, Solomon King, and other New York publishers.
Now and then a frontispiece or a few cuts in the text of a book would be wanted; but most
of the work required was for labels for cotton goods, or soap-stamps, hand-bills, playing-cards,
and such like. Books were not profusely illustrated as now, — what illustration was used was
generally copperplate; and the young engraver knew what it was to be out of work and at
times without a cent in his pocket. But he persevered. In 1831 he was able to make a voyage
to England, probably incited to that by the coming to this country, in 1829, of Abraham J.
Mason, an English wood-engraver, from whom he may have had introductions to Thompson,

MEETING OF JACOB AND JOSEPH.

ENGRAVED BY J. A. ADAMS.

FROM HARPER'S ILLUMINATED BIBLE.

Bonner, and others. He was gone four months, seeing, learning, and his ambition spurred by what he saw to higher effort. Two or three years after his return he drew (a copy from a copperplate) and engraved a frontispiece for the *Treasury of Knowledge*, published in New York by James Conner: on a small duodecimo page a full-length portrait of Washington, in a square $2\frac{1}{2} \times 1\frac{3}{4}$ inches, surrounded by circular subjects rather less than a nickel cent, the arms of the thirteen States of the Union enwreathed with oak and laurel, a figure of Liberty at top, — the minuteness and delicacy of which may challenge comparison with anything I know of in engraving on wood. This was executed in 1834. Not so minute, but of equal excellence, is another frontispiece, of the same size, with figures representing Europe, Asia, Africa, and America, and views of Paris, Rome, Calcutta, Cairo, London, and Buenos Ayres. The Washington frontispiece was followed by two cuts for the *Cottage Bible*, also published by James Conner, long since, I believe, out of print. Impressions of these, the *Massacre of the Innocents* and *Jacob's Dream* (the latter after a picture by Washington Allston), drawn on the wood by Adams himself, — not burnished proofs, but prints on hard paper by the hand-press (his own beautiful printing), — I have in my possession, given me by him. His own collection of proofs, and many blocks, were lost in the great fire of 1835. The cuts for the *Treasury of Knowledge* and the *Cottage Bible* were also destroyed by fire some two years later.

The two last-named engravings are of his best, if not his very best work, yet unequalled in this country, and worthy to rank beside the best of the great old time in England. Nothing more sweet or tender has been done than the *Dream*: the figures well drawn; the distant angels rendered more aerial by an almost imperceptible white line, lightening but not destroying the first cutting; the clouds pure in line and fine in tone; the foreground a rich white line; the whole cut as good as if it had been done by Thompson, or Branston, whose style it most resembles. The *Massacre*, after Coignet, also drawn by himself, a bolder cut, is almost if not quite as good. A little figure of a soldier coming down the steps is cross-lined so finely that I did not at first observe the cross work. The intention had been simply to reduce the color, to give air and distance; but with true artist feeling, though the lines were not to be seen, he had been as careful with them as with the first cutting, and they were as well disposed as the first and in harmony with them. No better work, I would repeat, than these two cuts has been done even in the best time of England. Their size is about $4\frac{1}{2} \times 3\frac{1}{2}$ inches.

Of about the same date, I imagine, is a vase that I would have taken for Thompson's engraving: I can give no higher praise. A cut of *Canute's Reproof*, and a frontispiece to *Evenings at Home*, both drawn by Chapman, and several other cuts printed on a delicate gray ground, with high lights of white, are equally beautiful and as highly finished. A small cut of *Joshua* commanding the sun to stand still, drawn by Chapman, and engraved for some Scripture story-book, deserves especial notice for the daring use he has made of solid black. In the early part of 1835 he began to copy a series of *Bible Illustrations* published by Seeley, of London, chiefly landscapes about the size of an octavo page, engraved by Thompson, S. Williams, Orrin Smith, Powis, and others. Some eight of these were transferred and engraved by him. One copied from Powis, one of Powis's best landscapes (no man then engraved better landscapes), is so exact to the original, even in character and value and vigor of line, as to be easily mistaken for it. He was to engrave the whole series, but was prevented by the sudden death of his employer. The eight were, I believe, afterwards published along with the originals of the remainder of the series (by arrangement with the London house) by Van Nostrand & Dwight, of New York. I would also note a landscape, of his own putting on the wood, from an oil-painting by Morse, the first President of the National Academy, which in its clearness and purity of line reminds me again of Powis.

One other of his principal works is the *Last Arrow*, engraved in 1837 for the *New York Mirror*, and afterwards printed (Mr. Lossing tells me) in the *Family Magazine*. The drawing is by Chapman; the subject is the pursuit of an Indian by some settlers, — the Indian, on a rock

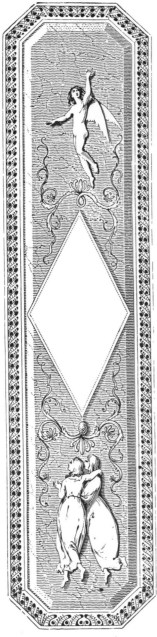

PART OF PAGE BORDER.
From Harper's Illuminated Bible.

in the foreground, aiming his last arrow at his enemies; a woman with a child in her arms is at his feet. The size of this engraving is $7\frac{1}{4} \times 4\frac{3}{4}$ inches. It is bolder in treatment than the *Jacob's Dream*: the two I consider his best productions. I have an impression given me by Mr. Adams, and he has a proof of it. I know not where else it may be seen, except badly printed in the *New York Mirror*, or in Vol. VI. of the *Family Magazine*, wherever those obsolete works may yet be preserved. Proofs and blocks burned, there is little to be got at, unless by chance at some old bookstore, by which the real worth and extent of his work can be fairly estimated. As in the case of Anderson, scarcely anything is accessible even to the most perseveringly curious. Besides himself I have found but one man having any proofs of his cuts. To him, an engraver, of Hartford, Mr. S. H. Clark, I am indebted for sight of some things of which even Adams has not impressions. More may be scattered here and there, and copies may yet exist of the *Treasury of Knowledge* and the *Cottage Bible;* but who can tell where? He is to be known now only by the cuts in the Bible published by Messrs. Harper.

This was projected in 1837, at a time when he wanted employment for his pupils. He thought that an octavo Bible, with a number of small illustrations, would command a sale; and for this he took transfers of some forty English cuts after designs by Martin, Westall, and others. These engraved, it appeared worth while to add to the number. So the project grew; and, being taken hold of by the Harpers, resulted in the larger quarto edition so well known, which yet keeps its ground as the best illustrated American Bible. Its first appearance was in 1843; and it has retained to the present day its original form, "embellished with sixteen hundred historical engravings by J. A. Adams, more than fourteen hundred of which are from original designs by J. G. Chapman." The exceptions are the transfers before mentioned, square cuts, for which, when the intended size was enlarged, Chapman drew a set of elaborately ornamented borders; and the half-page landscape vignettes, also transferred or copied, from cuts after Harvey, these last better engraved than the bordered cuts, as copies from better originals might be. There is none of Adams's own work in these transfers; and the numerous small figure and landscape illustrations by Chapman are all from the hands of his pupils, John Gordon and Robert Roberts, or of other engravers employed by him, — as may be expected, of very unequal

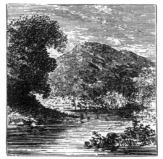

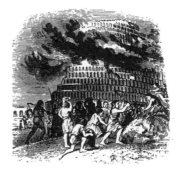

FROM HARPER'S ILLUMINATED BIBLE.

merit, done under his direction only, with perhaps here and there some manual assistance in touching — correction of drawing or improvement in tone or effect. All actually and entirely of his own work are the frontispieces and titles to the Old and New Testaments, the initial headings

ENGRAVING BY J. A. ADAMS. — HEADING TO MATTHEW.
From Harper's Illuminated Bible.

to the first chapters of Genesis and Matthew, the ornamental page borders (except those of the Family Records), and Chapman's borders to the square transfers before spoken of. Through the courtesy of Messrs. Harper, I am able to give specimens of the Master, as well as of the general character of the fourteen hundred small cuts. Of these I can but regretfully say that the electrotypes are only an insufficient and unfair representation. Yet more have I to regret the impossibility of proving by even any reproduction of the engravings the justice of such praise as I have rendered to his other works.

The firm, honest exactness and clearness of Adams's work, executed with thorough knowledge of and as thorough adaptation to the needs of printing, is plain here as in the engravings I have previously described; and if we miss somewhat of the variety of line and richness of color and tone which I have claimed as belonging to his other works, that is certainly attributable to Chapman, whose precise and mechanical drawing, in formal imitation of copperplate, every line, however delicate, set down with perfect distinctness, required an almost slavish following, which must have sorely tried the patience of the engraver. In objecting, however, to this style of mock copperplate, I must not do injustice to Chapman. His freest drawings were very beautiful. I have one lying before me, the initial heading for the first page of some child's book. It is most delicately, yet firmly drawn, the faintest line sharp and clean, as in an etching, — only some little light tint rubbed in in the background. It would furnish an excellent lesson for the but too often hasty and sloppy draughtsman, a sufficient answer to those who would speak slightingly of "only a draughtsman on wood." Drawing, engraving, and printing were all marvels at the time of this book's production; and it well deserved the popularity it immediately obtained, and which it yet holds. It has a special value for the student of American engraving.

In our judgment of Mr. Adams, as of Dr. Anderson, the difficulties he encountered, not only in his first essays in engraving, but when he had reached his full success, must be borne in mind. When his Bible went to press, he had to prepare (technically, to overlay) his own blocks. There was no printer capable of that. Certain improvements, yet in use, in the press itself are also his work. He was the first electrotyper in this country, the inventor also of several improvements in that process. And to him engravers are indebted (though it be but a question-

able indebtedness) for the knowledge of how to transfer a print to the block, to save the trouble of drawing, or to procure a perfect fac-simile. It was for some time his secret, and safe in his power, sure to be only well used, not employed as an aid to idle incompetence; but it was stolen from one of his pupils, and so became common, to the depravation of those who used it out of sheer laziness or for the sake of cheapness, and to the injury of unfortunate apprentices compelled to travel in such fashion (like swimming on corks) to the destruction of all self-reliance. Adams was an artist, — so unharmed by any process. In his early days he was a conscientious and diligent student, drawing from casts and from the life, knowing well that only through artistic study can the engraver claim to be considered an artist, or perfect himself in his special profession. The Bible was published in 1843. The sale was such that his share of the profits gave him means to travel and a competence for life. He made three visits to Europe, and was there altogether eight years. Since his return, his inventive genius engaged in other matters, the world of Art has unfortunately lost him. To sum up, his graver drawing is always good, and in the mechanism of his art, in the disposition and perfection of lines, his engraving will take rank beside the best of English or other work. I may add as worthy of remark, that his printing of his own engravings is equal to the best of any time, — better than anything to be obtained at the present day.

Here it may be well to notice some special differences in the methods of procedure of our early engravers. Anderson and Adams soon found the advantage of having the drawing fairly made upon the wood, which left them free to invent their own lines, and which gave even to Anderson, who never reached the originality of Adams, a free-handedness not to be obtained by their first process of engraving upon *a blackened block*. Adams's work has a distinguishing character of its own. Anderson, though his admiration for Bewick limited his range, was yet free-handed. In Bowen's work what we find, however good, is neither original nor free-handed. He is simply a careful copier: owing to the fact that he never departed from the first method of working. In 1831, some years after Adams, following the example of Anderson, had begun to make his drawings upon the wood, Bowen was still engraving on the black block: perhaps easier to him, in so much as it was similar to the process of copper-engraving, — to his practice in which also much of his excellence may be attributed. I had difficulty in being convinced that his work was not altogether from transfers, till assured to the contrary by Mr. Mallory. He writes to me of the *Young Lady's Book:* "All the cuts were done on a black ground; and all that was done in Boston was executed in that way." "In working on the black ground the copy was reversed by a mirror, and constantly under the engraver's eyes." Mr. Crossman and Mr. Kilburn (with Mr. Mallory pupils of Bowen) confirm his account of the then usual procedure. General outlines being traced, the engraver had but to closely follow, line by line, the original before him, — a method insuring mechanical exactness, but fatal to the individuality of genius, fatal to anything to be called art. Adherence to such a course accounts for Bowen's inferiority to Adams and Anderson. He was, however, a notable man, not only for his own work, so qualified, but also for the pupils who came from him, — Hartwell, the brothers Devereux, Greenough, Croome, Childs, Crossman, Mallory, and Kilburn (the last three yet living). George Loring Brown, the painter, and Hammatt Billings, the architect, began life also as wood-engravers with him.

CHAPTER III

NGRAVING on type-metal, and occasionally on brass, in relief for letter-press printing has been practised for many years in the United States; and is often as well executed as are wooden cuts, for the same purpose, on the other side of the Atlantic. So writes Isaiah Thomas in his *History of Printing*, dated 1810. I take note of it, because in the course of my inquiries I have stumbled upon a little book, "with nearly five hundred *cuts*," published by this same Thomas, at Worcester, Mass., in 1788: five years before Anderson's first attempts on wood. The title of the book is as follows: — *A Curious Hieroglyphick Bible; or select Passages in the Old and New Testaments represented with Emblematical Figures, for the Amusement of Youth, designed chiefly to familiarize tender Age in a pleasing and diverting Manner with early Ideas of the Holy Scriptures: the first Worcester Edition.* It is impossible to say with certainty whether these "cuts" (generally about an inch square, frontispiece and some few larger) are on wood or not. But they are so rude that they might easily have been done upon type-metal. The book is a reproduction of an English work. The "first Worcester edition" does not prove that it was *printed* at Worcester, while it does imply an earlier appearance elsewhere. Thomas speaks of *books* sent to England to be printed; and this may have been printed there, even with the American title-page. Without further evidence I hold to Dr. Anderson's right to be considered the first engraver on wood in America. No less the *Hieroglyphick Bible* demanded a passing notice. I resume the course of my history.

JOHN H. HALL, born at Cooperstown, New York, "Anderson's third pupil" (I suppose taking some few lessons from him — else self-taught), began engraving in 1826, afterwards prac-tising at Albany, and in 1830 finding employ-ment with the firm of Carter, Andrews, & Co., at Lancaster, Mass., whence he removed to New York. I find his best engraving in a *Manual of the Ornithology of the United States and Canada*, by Thomas Nuttall, published by Hilliard, Gray, & Co., Boston. The date of the first edition I do not know; the second is 1840. I have before me, in a book lent to me by Mr. Mallory, proofs of these cuts bearing date of 1832–3. Some of them, drawn in pencil by Hall himself, are copies from Bewick or from Wilson's *Ornithol-ogy;* some were drawn from nature by William Croome. The two specimens here given (though

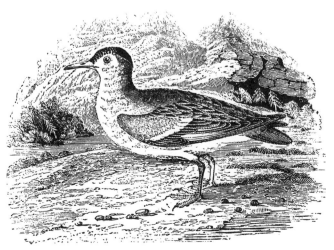

FROM THE "MANUAL OF ORNITHOLOGY." — BY HALL.

FROM THE "MANUAL OF ORNITHOLOGY. — BY HALL.

AFTER BEWICK. — BY HALL.

AFTER BONNER. — BY HALL.

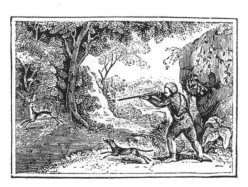

DRAWN AND ENGRAVED BY CROOME.

but poorly phototyped from badly printed impressions) may still serve to show the character of these cuts: done in the manner of Anderson, — the white line of Bewick, — and, I think, in every respect as good as Anderson's, — of greater merit in so far as Hall's engraving of Croome's drawings had to be of his own invention. He did good work also for the Smithsonian Institute at Washington. From Mr. Mallory's book I am able to give two other small cuts: the copy of one of Bewick's tail-pieces, and a reduction from a cut by Bonner, drawn by Harvey. I note also some copies, dated 1834, of cuts by S. Williams, very true to the peculiarities of the master. In 1849, stricken with the gold-fever, Hall went to California, and died there.

WILLIAM CROOME was a pupil of Bowen. His engraving is of the same character as Hall's. In the Mallory book are a few fair copies from Harvey (cuts by Jackson, I think); some cuts from drawings by Tisdale and Johnston; very many of his own drawing: cuts of fables, animals, landscapes, figures, etc., very little inferior to the generality of Hall's work. Later in life he gave his time to designing for bank-notes. He drew well on the wood, and is said to have been a good painter in water-colors.

In this same Mallory collection also I find proofs, bearing dates from 1830 to 1835, of cuts by Ezra Atherton (copies from Bewick, Harvey, and others); by Alonzo Hartwell, said to have been the best of Bowen's pupils, but the cuts here not answering to that; by Fairchild of Hartford, Alden, Wright, Greenough, and Minot (none requiring particular notice); and by George Loring Brown, the painter, whose engraving seems to have been not below the average of his contemporaries, with some promise of possible later excellence. In 1832 he went to Paris, and worked for a while on the *Musée de Famille*. Few engravers were there then: the best, Charles Thompson, brother of John. Some cuts by G. Thomas Devereux, also in the Mallory collection, should not be disregarded: two or three, engraved (Mr. Mallory informs me) on the black block, very accurately and with much feeling, copied from cuts in the second series of Northcote's *Fables* (London, 1833); and a large cut (here given) after Thurston and William Hughes, which, whether on a black block or from a transfer, has almost as rich a line as the original (however feebly represented here), and is nearly as good as the best work of Anderson himself. I ought not to omit, against my own depreciation of Hartwell, that in 1850 he received the silver medal of the Massachusetts Charitable Mechanics' Institution, for the best specimen of engraving on wood. I do not know who were his judges or who his competitors. I go back again to 1829.

AFTER WILLIAM HUGHES. — BY G. T. DEVEREUX (1835).

In this year Joseph Andrews, an engraver on copper, also a pupil of Bowen, joined the firm of Carter, Andrews (his brother), & Co., already in business at Lancaster, Mass., as printers and binders; and so began there an establishment for engraving and general book-work. *Peter Parley* was then having a wide circulation, the books all illustrated, more or less. Hall came to work in the house; Atherton, Mallory, Minot, were taken as pupils; Croome was employed as designer. Others, draughtsmen and engravers, Nutting, O'Brien, Worcester, joined afterwards. So many as fourteen engravers, on wood and copper, were at one time employed, — so many as seventy hands in all, type-founders, stereotypers, printers, bookbinders, &c.: till the establishment failed and broke up during a financial panic in 1833.

In 1834 Bowen, Hartwell, and John C. Crossman formed the "American Engraving and Printing Co.," afterwards altering their style and obtaining a charter of incorporation as a joint-stock company under the name of the "Boston Bewick Co." Mallory, Croome, and others, joined them. They published the *American Magazine*, of similar character to the London *Penny Magazine*, of which at that time two editions were in course of republication in this country, — one in New York from imported plates, one in Boston with re-engraved cuts by B. F. and J. J. Greenough. The two volumes of the *American Magazine* contain some five hundred illustrations, poor in execution and coarse. In 1836 the company's premises were burnt down, and the company failed. "There was," writes Mr. Mallory (to whom I am indebted for information as to these experiments), "another dispersion of the engravers"; new combinations and arrangements, — some removing, others quitting the business altogether.

In 1829 (again looking back) Abraham J. Mason of London, a man of some versatility and a good engraver, came to New York, well introduced by Lord Brougham and others to scientific and professional Americans. His work, though wanting the power of his master, Branston, was refined, and likely to attract notice. In 1830 the National Academy of Design,

CHAPTER IV

N the history of wood-engraving in America we cannot omit to notice the influence of illustrated newspapers and magazines. The earliest in the country, according to Lossing (*Memorial of Anderson*), was a weekly illustrated sheet called the *Family Magazine*, of which the first number appeared in April, 1833, published in New York by Justus S. Redfield (the same who published Chapman's Drawing-Book), a brother of the engraver Redfield. It was, says Lossing, "wholly and profusely illustrated by engravings on wood," and "held the field almost without a competitor through eight annual volumes, issued in monthly parts." Adams's *Last Arrow*, writes Lossing to me, "was published in the *Family Magazine*. He had just completed it for another purpose," [for the *New York Mirror*,] "and was printing it with a slightly tinted ground, in the autumn of 1837, when I was taking a fortnight's lessons of him, to enable me to illustrate a little literary work I was then editing at Poughkeepsie, New York." In 1839, Lossing himself edited the *Family Magazine*. His account should, therefore, be trustworthy, yet is not altogether correct. The *New York Mirror* began in July, 1823, and at the close of the fifth volume, July 5, 1828, I find stated, "Engravings shall be continued as heretofore." Vol. VIII., 1830-1, has a list of seven engravings on wood, poor cuts certainly, but engravings for all that; Vol. XIV., 1836-7, has five engravings on wood, one by Adams, the *Studious Boy*, after a picture by Mount; Vol. XV. has no fewer than twenty-one, four by Adams, including the *Last Arrow*, his best work. The *New York Mirror* clearly, therefore, antedates the *Family Magazine* as an illustrated paper; and the "profusely illustrated" may be taken with some salt. The *Mirror* also is a volume "adorned with numerous engravings"; and the "almost without a competitor" from 1833 to 1840 will not stand in competition with the fact that not only the *New York Mirror*, but the Boston *American Magazine* and two reproductions of the London *Penny Magazine*, had existence within those dates.

Two years later (1842) the only illustrated newspaper in New York [and I believe there was none elsewhere in the country] was the *Sunday Atlas*, illustrated to the extent of a small portrait, four inches square, on the front page of the paper. The *Mercury*, not to be outdone, thereupon embellished its Sunday issue with a series of outlines about twice the size of the *Atlas* cuts, illustrating a sort of travesty of a play, "Beauty and the Beast," then being acted at the Bowery Theatre. The character of these cuts may be judged of from their cost, — from two to four dollars each. I believe the *Herald* followed suit, indulging in an occasional embellishment. Then there was a yearly illustrated broad sheet called *Brother Jonathan*. In 1843 a certain Chevalier Wykoff started his *Picture Gallery*, a large open monthly sheet with a few coarse and very common cuts. This lasted only some three months; but was the occasion for

bringing out an English engraver, George Thomas, so well known afterwards for his designs for bank-notes, before he returned to England to make a reputation as draughtsman on the wood, and painter. In June, 1850, *Harper's New Monthly Magazine* made its first appearance, soon followed by the *International Magazine* (surely an unfortunate name in those days), published by Stringer and Townsend. *Godey's Lady's Book* and *Graham's Magazine* had also cuts occasionally.

The first volume of *Harper's New Monthly Magazine* bears date "from June to November, 1850." It was not profusely illustrated at first, and the few cuts in the early numbers, by Lossing and Barrett, are very poor in quality. The first cut in the Magazine, a portrait of Alison, appears at page 134. Two other portraits, Macaulay and Prescott, follow, at pages 136 and 138. A few fashion cuts complete the illustration-list of No. 1. No. 2 has five small landscapes and three fashion cuts. No. 3 has half a dozen cuts copied from the English *Art Journal*; a fair portrait, after Brady, of Zachary Taylor; and fashion cuts. By the time we reach Vol. X., 1854-5, there is a tolerably numerous array of cuts, by the old hands and others: some good figure subjects, of his best, by Richardson; and neat landscapes, with and without figures, by John Andrew, Richardson, Bobbett & Hooper, and N. Orr & Co.; some good animals also, copied I imagine from Harvey. Thence to 1871 the engraving preserves a dead level. The Magazine had obtained a sale of fifty thousand in the first six months. I shall have to give a special notice of the improvements in later years.

In 1851, T. W. Strong, engraver and publisher, projected the first American illustrated newspaper worthy to be so called. Strong had been a pupil of Elton, but had been taught so little during his pupilage, that, when on a visit to Paris he sought employment from Quartley (an English engraver in business there), his specimens were only laughed at. With true American pluck he asked leave to practise unpaid in the atelier of Andrew, Best, & Co., and so worked till they were glad to pay and desired to keep him. His work, honest and bold, may be seen in the frontispiece of the *Illustrated American News*, drawn by Dallas, the first number of which he brought out on the 7th of June, 1851. The drawings for the paper were principally by George Thomas, Wallin, Hoppin, Bellew, and Hitchcock; the engravings by Strong himself, Anthony (then his pupil), the Orrs (N. and J. W.), and two newly arrived Englishmen, "Frank Leslie" and John Andrew. The engravings cannot be called better, or much worse, than the mass of "engraving" done at the present day for cheap newspapers. The attempt continued for only a few months, the last number appearing on the 12th of March, 1852.

In the following year an endeavor to revive it was made by the great show-man, Barnum, and Beach of the *Sun*. This second *Illustrated News* of New York lasted from the 1st of January, 1853, to November 26th of the same year. Failure again. The cuts were much like those in the earlier paper.

Strong's failure with the newspaper had taught him something of popular requirements. *Diogenes — his Lantern* was brought out by him, making a six months' volume, from January to June, 1852, edited by John Brougham, with cuts in imitation of *Punch* from drawings chiefly by Bellew. That not taking, Strong in the same year started his *Yankee Notions*, which reached a sale of forty-seven thousand, and was profitable to the enterprising publisher for fifteen years. McLenan (a designer of much originality and spirit and a good draughtsman), Hoppin, and Howard drew for it; Brougham and Artemus Ward wrote in it. It may also be worth telling, in connection with the *Notions*, that Edison, the telephone inventor, began life under its auspices, hawking it for sale. The success of the *Notions* prompted Strong to another imitation of *Punch*, — *Yankee Doodle or Young America*, — in 1856. This lived but six months.

Frank Leslie's Illustrated Newspaper came out in December, 1855, and *Harper's Weekly Journal of Civilization* began its career in January, 1857. An unsuccessful rival, under the conduct of Anthony, with drawings by Eytinge and Nast, begun in November, 1859, collapsed after a few months. *Gleason's Pictorial*, in Boston, was in competition with these, — followed by

Ballou's illustrated publications. *Vanity Fair* was begun a little while before the late war, but did not last, — the times too serious for jesting.

All these endeavors, successful and unsuccessful, I chronicle on account of their influence on engraving. Most certainly, as demand creates supply, (so it is said, though it is the supply that creates demand in many cases,) these publications, even the most short-lived, summoned forth a numerous array of young or new engravers. The influence upon the art, as distinguished from benefit to the professors, is another matter. It ought to have been educative and good. It was good to this extent: it took men away from the tendency to mere fineness of work, which, following the decadent work of England, seemed threatening destruction to everything like artistic excellence. But while doing this, the advantage to be gained from a larger treatment — testing an engraver's knowledge of drawing and his power of line — was neutralized by the necessity of unstudious haste to meet the requirements of rapid publication. It may be indeed a question whether the amount of slop-work, almost necessitated by a newspaper, has not done more to deteriorate the character of engraving than even the pursuit of mere mechanical excellence into which the art was falling. "Anything good enough," so that it was first in the market, did not help to elevate the art. Some little attempt was made by Leslie, in 1867, when I first came to this country, to improve the work in his paper; but the effort lasted only a few months. I suppose it did not pay. The unknowing public did not demand improvement. Of Leslie's other numerous illustrated publications there is no need to speak: they were and are of the same description as the newspaper. Nor of *Harper's Weekly Journal of Civilization* up to the same date, 1867, and even for some years later, can I as an artist speak with more satisfaction. I find there only a few good cuts, much very common work (I speak simply of the engraving), a certain general improvement crawling through the first dozen years; but nothing to which I could refer an engraver for his learning or to stir his emulation. The earlier newspapers (Strong's, Barnum's, Anthony's), following the example of the London *Illustrated News*, were at least not sparing of illustration, such as it was. The cuts in the early numbers of *Harper* are few and far between, of no great importance either.

The first number of the *Journal of Civilization*, January 3, 1857, contains four two-column cuts about three inches high, and two comic cuts, one a column and a half, the other three columns wide. This is all, except the well-known heading, in the "illustrated" paper. No. 2 affords a yet poorer lot of illustration, — eight small cuts, not one of them three inches square. No. 3 ventures on a cut across the top of the four columns, two nearly three-column cuts, and a column portrait. No. 4 really makes a show, — eleven cuts in the two centre pages, nothing elsewhere. Thenceforth there is a gentle increase of embellishment, mostly common cuts, such as might illustrate cheap octavo and duodecimo books: landscapes, portraits, with occasional comic cuts, social or political, of the usual excellence. By the time we come to No. 16 there is a beginning of newspaper work, representations of events, a good portrait of the then Governor of New York, and three half-page cuts of *Hon. E. Everett in the Assembly at Albany*, and *Miss Rothschild's Wedding;* besides two pages of small cuts of news from Nicaragua, — fairly engraved and well printed; and a batch of comics. A later number has a portrait of Palmerston and half a page of English news, suggestive (perhaps incorrectly) of importation of casts. Before the six months are out we have a full front-page engraving, portraits of Prince Frederic William of Prussia and the Princess Royal of England; and soon after there is a full-page royal Victorian "drawing-room," and proper newspaper complement of portraits, scenes, fashions, and caricatures. A two-page cut of the Collins steamship astonishes us in No. 39. But neither engraving nor printing improves at the same rate. Indeed, in this first volume there is little to notice as *engraving*, except some good portraits from drawings by S. Wallin. It may be worth remarking that Homer and Hennessy seem to have here made their beginnings as draughtsmen. As the years go on, larger cuts, with necessarily bolder work, are ventured on. There is daring, if little art: evidence of a certain mastery of the graver gained through the larger practice, —

ENGRAVED BY HARLEY. — DRAWN BY DARLEY.

From "The Riverside Magazine." Published by Hurd & Houghton.

evidence also of always haste, that enemy of perfection. During the War much attention to art was not to be expected: the earliest news had to be cared for. Again my criticism refers only to the engraving. The sketches of Waud, Homer, and others, do not come into my province, except so far as I may remark, while recognizing their originality and vigor, that the drawings on the wood could only be hurried, and the engraver also had to work against time. Exceptions of course may be found. A masterly portrait of Martin Van Buren, drawn I suppose by Wallin, whose portraits are always good, appears in No. 293, Vol. VI., vigorously and beautifully engraved and as well printed. There is no engraver's name to it. In 1863 (Nov. 21) I find another good piece of large work, — the *Great Russian Ball*, drawn on the wood by Winslow Homer. By 1871 the improvement is very noticeable. Designs and engravings assume a more

ambitious character, both in size and in effect. But the engraving is not much improved. Allowing for exceptions, I would rather call it more careless than ever. And by this time so great a proportion of foreign work occupies the paper that it is impossible, unless led by names of known engravers (seldom allowed to assert themselves in an engraving establishment), to place anything as really native talent.

Anderson and Adams — it cannot be too often repeated — drew with the graver. Had Anderson's Ridinger and Teniers prints been taken as exemplars, [but it would seem that these had passed out of sight, disregarded and forgotten,] the large work required in the newspapers had been a noble education for the engravers. Even in Anderson's rudest work every line is the line of an artist, a line with meaning: the ordinary newspaper cutting had no meaning. Except in the portraits, the one object appeared to be to keep color. Form might take care of itself. Certain conventional lines, a little rougher or a little smoother, not always that, served for skies, walls, ground; a flatter line passed for water, and a short dig with the graver for trees. It was conventionality of the worst kind, not formality respecting some recognized rules, but formality without perception, the work of sheer ignorance and absence of mind. Men for so much a week got into the way of " engraving," knowing and caring nothing for it as an art. Even the better class of work suffered from this habitual slovenliness and want of drawing. Bad habits cannot be acquired with impunity. It was with some hope of remedying this state of things that in 1871 I brought out an eight-page folio of large engravings, called *American Enterprise*, the drawings chiefly by Hennessy, the engraving by W. J. and H. D. Linton and Alfred Harral (a pupil of Orrin Smith). The largest, *Bacchus in America*, 25 × 16 inches, drawn by Hennessy and engraved entirely by me, I may notice as I believe the largest wood-engraving ever done as a studied work of art, [larger cuts not artistic there certainly are,] and also because it was an endeavor to recall attention to the old white line of Anderson and Bewick.

Almost simultaneously with this, *Every Saturday* (Fields, Osgood, & Co., Boston) came out as an illustrated newspaper, promising attention to art, and looking to a successful competition with *Harper's Weekly* by means of better paper and printing. Its early numbers were filled with electrotypes from the London *Graphic*, on the use of which, indeed, the speculation was based. As opportunity offered, American work supplemented the foreign; but when the Franco-Prussian war began, news again took the place of art: quite right perhaps from a publisher's standing-point, but in this instance not advantageous even to the publisher. *Every Saturday* did not live through a second year.

Our Young Folks (Ticknor & Fields, Boston) an octavo monthly magazine, begun. in 1865 and continuing to 1873, may be referred to as showing the average ability of that period: including the names of Davis & Speer, Morse, Redding, Matthews & Robins, N. Orr, Kingdon & Boyd, Richardson, Kilburn, Cullen, Anthony, and Linton, as engravers; and Eytinge, Fay, Fenn, Hoppin, Homer, Hennessy, Champney, Davenport, Barry, Herrick, Darley, Forbes, Sheppard, Waud, White, Mary A. Hallock, Jessie Curtis, and Lucy Gibbons, as designers.

Hurd & Houghton also, in 1867, '68, '69, '70, issued a monthly, the *Riverside Magazine;* the cuts in the letter-press generally inferior to those in *Our Young Folks*, but with more ambitious effort in the larger unbacked page designs. Chief of these are some designs by John La Farge, engraved by Henry Marsh. The engraving I reserve for future consideration. There is also a series of subjects by H. L. Stephens, illustrating Nursery Rhymes, to be noticed both for the fancy of the designer and for Harley's excellent engraving, — only too much refined, and so losing force and effect. Harley's best work in figures is, however, to be seen here; his best of all, more vigorous than the rest, but equally careful, is one cut of *Jack of the Mill*, from a drawing by Darley, in Vol. IV. p. 332. An excellent cut of *Robinson Crusoe*, by Marsh, from an unusually careful drawing by Nast, is borrowed from Vol. II. p. 145. (See next page.)

Scribner's Magazine, begun in November, 1871, demands with *Harper's* after same date more distinct attention.

Saturday, hardly therefore to be classed in the series I am chronicling; and in 1875–6 and following years Whittier's *Mabel Martin*, Longfellow's *Skeleton in Armor* and *Hanging of the Crane*, and Hawthorne's *Scarlet Letter :* the figure subjects in these four by Mary A. Hallock (now Mrs. Foote), the landscapes by Waud and T. Moran, the initials and ornamental work by Harley and Ipsen; the engraving chiefly by Anthony. In the early part of the same gift period, before the beginning of their *Magazine*, Scribner & Co. brought out Dr. Holland's *Kathrina* (1868–9) and Mrs. Browning's *Lady Geraldine* (1869–70), both numerously illustrated by Hennessy, the *Kathrina* having also some landscapes by Griswold. In both books the engraving goes under my name. In the *Lady Geraldine* I had the help, for almost all the landscape part, of Alfred Harral, my fellow-worker in early years. The *Kathrina* was entirely my own. In it I may point out some difference of style, the white-line method being followed throughout. In 1868 the American Tract Society produced the *Women of the Bible*, already referred to, with drawings by F. A. Chapman, some of

ENGRAVED BY ANTHONY.

From "The Scarlet Letter." Published by James R. Osgood & Co.

them of excellent feeling and finish engraved by Hayes. Nor were Messrs. Appleton & Co. idle. I find between the above-given dates, published by them, Bryant's *Song of the Sower* (1870–1), with forty-two engravings; Bryant's *Story of the Fountain* (1871–2), forty-two engravings; Bryant's *Little People in the Snow* (1872–3), with designs by Fredericks; and by Fredericks also, *A Midsummer Night's Dream ; —* the last two engraved by Bobbett, with tint behind the black-line work, — very effective. The *Dream* is altogether an imposing book.

These gift-books, produced with much care and at great cost, however differing in merit, and whatever of demerit the critic may impute to them, certainly afforded practice and encouragement to both designers and engravers. If full advantage were not taken by commensurate improvement, whether in drawing or in engraving, the fault lay not with the publishers. For a further great incentive to good work we are indebted to the enterprise of Messrs. Appleton in the issue of the most important book of landscape that has appeared in this country, their *Picturesque America*, now complete in two handsome volumes, but first published in monthly parts, in 1872, '73, '74. The imperial quarto size of the page gave scope to the engraver; and there was no more need either for the weakening refinement of small book-work or for the haste of newspaper requiring. The best landscapes engraved in this country (and nothing of later years in England will equal them) are to be found here. I have gone carefully through the two volumes, picking out without reference to names what seemed to me the best, — the most artistic, the most effective, the best also in manipulation, — and it may be well, if only for the sake of any of my readers desirous of perceiving differences of treatment, to make some attempt at classifying these. I take the first volume.

ENGRAVED BY W. J. LINTON.

From "Kathrina." Published by Scribner & Co.

I think nothing more satisfactory is to be found in this than the work of F. O. Quartley, an Englishman, but I suppose sufficiently acclimated to be noticed in the history of American engraving. Always firm and honest (terms to be repeated because expressing the first qualifications of an engraver), his cuts are sure to print well. They are also to be commended for artistic attention to differences and for careful gradating of color. I would rank him first among the Picturesque Americans. The cuts I signalize as his best (there are none bad, though of course there is a perceptible difference of merit, of carefulness, of success in rendering his subject) are *Castle Head, Mount Desert* (page 1), the *Tennessee* (page 52), *Chattanooga* (page 57), the *French Broad* (page 133), the *Entrance to Weyer's Cave* (page 212), the *Yellowstone* (page 292), and *Niagara* and *Under the Falls* (pages 432, 437): all admirable for both mechanism and feeling. These are all from drawings by Harry Fenn. Harley, I think, stands next to Quartley for general excellence: his engraving not so strong as Quartley's, but with more variety as well as feeling, and always, from the cleanness of his line, easy for the printer. Of his I select the *Lovers' Leap* (page 139), *Cliffs above Dismal Pool* (page 170), the *Date Palm* (page 189 — rich in line), *Entrance to Watkins Glen* and *Fairy Arch* (pages 240, 285 — of the same richness), *Soda Springs* (page 313), *Luna Island in Winter* (page 448), and *Ice Forms* (page 449): all very good, the last especially as an accurate representation of nature. These Harleys, also, are all by Fenn. Morse, whose general work most resembles Quartley's, — not so decided, but with more sense of tone, — has a good cut, *Interior of Natural Tunnel* (page 337), drawn by Sheppard, and one more characteristic of himself, *Main Street, Buffalo*, by Woodward (page 513). Filmer's best, I would say, are *Cliffs on the Yellowstone*, and the *First Boat on the Yosemite* (pages 301, 308), by Fenn, *Sentinel Rock* (page 475), by J. D. Smillie, and *At the Mouth of Russian River* (page 554), by R. Swain Gifford. There is good engraving, also, not too wearisomely to particularize, by Bogert, (page 84) the *Natural Bridge, Virginia;* by Langridge, (pages 54, 113) *Lookout Mountain* and *Mauch Chunk*, (page 454) *Trenton Falls*, and (page 379) *Hills near Moorfield* — exceptionally good; by Karst, (page 257) *Grist-Mills at East Hampton*, and (pages 347, 350, 351) the *Peaks of Otter, Natural Towers*, and *Jump Mountain;* by N. Orr, (pages 177, 225, 377) *Boat-Landing, Powder Mills*, and *Arched Strata;* by Richardson, (pages 224, 433) *Rising Sun* and the *Brink of the Horseshoe;* by Halliwell, (page 277) a *Planter's Home;* by Bobbett, (page 429) *Willamette Falls;* by Anthony (pages 441, 457) the *Whirlpool*, and *High Falls, Trenton*.

I need not spend so many words upon the second volume, though in no respect inferior to the first. Enough to mention a few of the cuts that first strike me: *Sinking Run above Tyrone*, and *Monument Rock* (pages 144, 181), by Quartley; *Dial Rocks, Laramie Plains* (page 171), by Filmer; *Truckee River* (page 193), by Morse; *Pine Forest on the Susquehanna* (page 213),

WALLS OF THE GRAND CAÑON. AFTER THOS. MORAN.

ENGRAVED BY ANNIN.

FROM PICTURESQUE AMERICA. PUBLISHED BY D. APPLETON & CO.

by Langridge; *Old Mill*, and *Silver Cascade* (pages 296, 297), by Harley; *Ascent of Whiteface* (page 414), by Slader, an Englishman, one of the most effective and at the same time the most delicate in the two volumes; and *Walls of the Grand Cañon* (page 509), by Annin, which I would call the most careful and the best of the whole series.

ASCENT OF WHITEFACE.—ENGRAVED BY SLADER.
From "Picturesque America." Published by D. Appleton & Co.

The English engravers (beside Quartley and Slader) represented are Henry Linton, Measom, Cranston, Palmer, Alfred Harral, and myself. The work of the two first named is rather below than above the general average: the best I find, *Goshen Pass* (Vol. I. p. 352), by H. Linton, and *Washington Rock* (Vol. II. p. 49), by Measom. Cranston has a good cut (Vol. II. p. 127), *Looking South from South Mountain;* Palmer a few in Vol. II., the best of which are *Moss Glen Cascade* (page 287) and the *Ausable Chasm* (page 415) — an excellent engraving, but wanting transparency in the water. Alfred Harral has many in both volumes. I would call attention to *Calking on the Neversink* (page 178), *Gorge of the Yellowstone* (page 296), and *Mill on the Antietam Road* (page 335), all in Vol. I., as specimens of his ability. It will not

hurt the engraver to compare these English cuts with the American, to note what differences of style may obtain. All such rivalry and friendly comparison helps to understanding. For this reason I may be suffered to speak also of my own endeavors. Surely not with bragging intent, but because I have sought to express the drawings under my hand in a fashion somewhat different from that of my fellow-engravers. In landscape subjects the drawings are usually worked in with Indian ink or sepia, and the engraver has to find the lines most appropriate to the same. There are exceptions to this manner of drawing, — as, for instance, the *Pine Forest* by Langridge (Vol. II. p. 213), a great part of which might have been drawn in pencil lines and engraved fac-simile; and the same peculiarity occurs in the light edges of vignettes, and in the lighter portions of other cuts, — light trees and grasses especially. Still, the mass of landscape drawing is tint; and, as said before, the engraver has to express that in lines. The fault of which I accuse almost all work of later days is that the engraver seems to care only for color, for the general effect of his cut, neglecting the making out of forms and the expression of different substances, letting two or three sets of unmeaning lines serve for everything. I hold that, on the contrary, the engraver should be always aware of the many differences of form and substance, texture, nearness, distance, etc., and use his graver as he would a pencil in distinctly and accurately rendering them. This is what I at least try to do, and for this I claim some distinction for my work. Beyond the recognition of this endeavor I do not ask for notice or especial praise. And while I may point out those of my cuts which I think are the best exponents of my theory and practice, I am free to confess that my work in other respects may fall short of others'. To give but one instance: I have done nothing of the same clearness, which means fitness for printing, nothing with so pure a line (taken only as line), as what will be found most noticeably in Quartley's engravings. In comparison with his my cuts in this *Picturesque America* have been generally coarse and harsh; yet I no less insist on the theory advanced above. Enough said, perhaps, to explain my position. I may now name what I consider the best of my work as examples, notwithstanding any failure on my part, of what should be aimed at by the engraver. The engraver may like to know also what an old hand would pick out as his best, not for finish so much as for sound work and expression.

In Vol. I., *Spouting Horn* (page 9), coarse, but every line drawn; *Tower Falls* (page 305), of the same character; *Berkeley's Seat* (page 373). In Vol. II., *Catskill Falls* (page 121); *Glimpse of Lake Champlain* (page 281); *Looking toward Smuggler's Notch* (page 286); *Pulpit Rock, Nahant* (page 395); and *Marble Cañon* (page 507). These are sufficient to indicate my ground of comparison; and, if the inquiry have interest, it can be pursued further.

Of *Picturesque Europe*, immediately following *Picturesque America*, I need, on account of its similarity, say but little. The illustrations, most of them engraved in England, are not on the whole so good as the American work. Those by Harley and Morse (there is one by Morse, a *Windmill at Rye*, Vol. I. p. 85, more vigorous than usual with him) are certainly much superior, both in feeling and in manipulation, to the multitude which passes with the name of Whymper, many of which are coarse in the worst sense of the word. It may be worth while for the student of engraving to refer to one at page 120, Vol. I., *Burnham Beeches*, if only to see the extreme of vulgarity — pretentious commonness, with utter disregard of what an artist understands as quality or value: coarse (Pannemaker out-Pannemakered), bold as ignorance, and most absurdly and unfortunately emphasized by contrast with a steel plate (also of the *Beeches*) immediately following. I name this as a specimen of mistaken daring, not as a sample of work called after Whymper, whose name is Legion. There are many good cuts with his ascription. Also others that I would like to notice, but wanting names I cannot speak of them as American or English. All exceptions allowed, the engraving in the *Europe* is not equal to that of the earlier work. In both books, however, I venture to assert that the average engravings on wood have more artistic merit than the finer and yet more mechanical steel plates.

THE MAYFLOWER AT SEA.

ENGRAVED BY W. J. LINTON. DRAWN BY GRANVILLE PERKINS.

CHAPTER VI

STAYED consideration of *Harper's Magazine* in order to resume my notice of it at the date at which I have now to take up its competitor. *Scribner's Magazine* was started in November, 1871, and for four or five years the two magazines (*Scribner's* and *Harper's*) preserved a pretty fair level, — with little of importance in either in the matter of engraving, only some improvement in paper and printing. In *Scribner*, during that period, I remark nothing very extraordinary save a general tendency toward fineness; a few good portraits; and a series of capital cuts (1875), from Moran's drawings, which appear to have been afterwards used (ill-used, so far as printing went) in the Governmental Report of Professor Powell's *Exploration of the Colorado River*. The subjects of these cuts (engraved by Bookhout, Bogert, King, Smithwick, Nichol, Müller, and others) demanded a certain degree of minuteness; and Moran's distinct drawing helped toward clearness and effectiveness in the engraving. These seem to have been the precursors of that race of microscopic littleness which has latterly marked the career of the two leading magazines, to which I shall have to call more particular attention further on.

St. Nicholas, Scribner's illustrated magazine for boys and girls, was begun in 1873, with work of the same character as that in *Young Folks* (whose place it presently took), but steadily improving. The designs and engravings, though generally lighter and less important than those in *Scribner's Monthly*, are by the same hands. One criticism may serve for both. Some cuts I shall have to notice elsewhere. Here I may give special commendation to the *Heart of Winter*, drawn by Moran, one of King's best engravings (Vol. IV. p. 65), and to Bogert's *Caught by the Snow*, Moran also (Vol. IV. p. 793), a cut full of refinement and delicacy without sacrifice of effect. I name these as samples of much excellent work.

Excellent work, too, has been done in *Harper's Monthly* since the competition with *Scribner*. I would direct attention to the admirable copies of subjects from Turner, by Annin (the *Datur Hora Quieti* is his), Hoskin, Measom, Johnson, and Bernstrom, in Vol. LVI., the number for February, 1878. And I may note some good copies of illustrations by the London Etching Club, to Milton's *L'Allegro*, in the same volume (No. 335, for April). I must also single out for praise the portraits of eminent musicians in No. 343, Vol. LVIII. The whole series is good; but I would speak of three or four as best, — the *Mozart* and *Schumann*, engraved by Johnson; the *Handel* and *Beethoven*, by Kruell. All are first-rate, honest, well drawn, effective, and delicate. I know no better heads anywhere; and I would point to these as examples of how a head may be best engraved on wood. There is a little difference in the work of the two engravers, Mr. Kruell's line being richer, showing also more knowledge of form. I shall have

CAUGHT BY THE SNOW. — ENGRAVED BY BOGERT.

From Scribner's "St Nicholas."

later to speak of Mr. Kruell. The *Mozart* may be given here as a fine specimen of the series; and I would have my readers remark, not only the qualities I have already noticed, but also how the cross-lining [I advocate cross-lining wherever it is useful] represents the powdered hair, at the same time keeping it well distinguished from the flesh.

In 1875, Messrs. Appleton began their *Art Journal:* to some extent a reproduction of the magazine under the same name published in England, but with addition of matter of more special American interest, and of engravings executed in this country. The average work so done for the *Journal* compares very favorably with that imported, so far as I am able to distinguish, wanting names sometimes for my guidance. Of the landscapes, Morse's and Karst's, from Woodward's excellent drawings, may stand among the best. There are good cuts, too, by Harley and Filmer; two by Filmer, after Peter Moran, in No. 41, very good indeed. It may also be worth while to notice, in No. 51, for the sake of comparing the different styles, as they stand facing each other, Morse's *Old Mill*, after Cropsey, and the *New Moon*, by Anthony, drawn by Appleton Brown. Differing as they do in manner, they are both capital in feeling. The critical inquirer may also examine two cuts in No. 57: *Up the Hill-side*, by Juengling, after J. D. Smillie, and the *Goat Pasture*, by Smithwick & French, after George H. Smillie; the last, in its freedom from unmeaning lines, very much the better of the two. In No. 54 Harley has spoiled a delicate, and in other respects good engraving, by his useless cross-lines in the sky. I here confine myself to the landscapes in the *Journal:* most of the figure subjects, whether from the works of native or of foreign artists, being my own engraving, which therefore I may be allowed to pass by. Two handsome volumes, *American Painters* and *Landscape in American Poetry*, issued last year, contain the best of the more artistic work of the *Journal:* the latter volume with drawings on the wood by T. Appleton Brown, engraved by Anthony, Harley, Lauderbach, Bobbett, Andrew, and myself. At page 88 here I would remark on another specimen of cross-lining, in the sky and water; the effect produced being a certain degree of luminousness, pleasant and well worth the care bestowed. The same treatment applied to grass and herbage is not equally satisfactory. A large amount of illustrations of "Art-manufacture" occupied, I suppose of necessity, the pages of the *Art Journal* during and after the Centennial year. There was not much room for more than mechanical engraving in these.

The years of National or International Exhibitions do not seem to be of much advantage to Art. I find but two noteworthy attempts to improve the occasion in 1876. *A Century After*, published by Allen, Lane, & Scott, Philadelphia, hardly fulfils the promise of its prospectus, "to illustrate this city and this State with engravings unapproached for artistic beauty, spirit, and accuracy by any previous publication." The engravings, from designs by Darley, Moran, Woodward, Hamilton, Schell, Bensell, and W. L. Sheppard, show nothing different from the

DATUR HORA QUIETI. — ENGRAVED BY ANNIN.

From "Harper's Monthly Magazine."

works I have already reviewed. Harley, Quartley, and Morse maintain their pre-eminence. There is an honest, unpretentious cut by F. Juengling, a *Scene in St. Mary Street*, at page 185; and Lauderbach's cuts are also neat and creditable. I would be glad to write up the Philadelphia engraving, having hitherto been so confined to the Empire City and the Hub; but indeed material is wanting. *Pioneers in the Settlement of America*, in two volumes (Samuel Walker & Co., Boston, on the monthly covers, Estes & Lauriat on the title-page), is of a higher character; with designs by Darley, vigorous as of old, Sheppard, Perkins, Waud, and Reinhart. No names appearing, I can only speak of the engraving as done under the careful superintendence of Mr. John Andrew; adding that some of my own may be detected by the white line by whoever is curious enough to further pursue that inquiry.

Referring again to *Harper's Weekly*, I may take the three years, 1877, '78, and '79, as fair specimens of progress in the paper. The list of designers for it, and of painters whose work is copied for it, is excellent. Better names are not to be had than Abbey, Reinhart, Shirlaw, Church, Perkins, Julian Scott, E. W. Perry, Eytinge, Champney, all appearing in these years. I do not think, though, that the engraving has improved commensurately. Certainly, there is the improvement, almost unavoidable after long practice, in the management of tints: some are very admirable, as mechanism. I allow, also, a greater feeling for tone and quality of line is shown occasionally, and effects of light and shadow are more cared for. Men can hardly work constantly without some gain both in perception and ability. But estimating the general character of the *engraving*, it bears yet the stamp of newspaper work, of which I have already spoken, perhaps sufficiently. Carelessness has walked hand in hand with knowledge, and the result of the combination has been slovenliness; for which, I think, the artists have been more to blame than the engravers. Nast's caricatures, bold and exactly lined, were of great use in the mere mechanism of fac-simile, but the mechanical dexterity thus obtained availed not much in washed drawings, where the engraver has to first learn the meaning of form, substance, and place, and then to invent, *that is, design*, the lines which shall best express thése. Little of this, outside of mere color and gradation of color, is to be found throughout the series of subjects which in *Harper's Weekly* ought to have given full scope for experiment and practice. The best things I find are the portraits; and it is hard to say why men who can

MOZART. — ENGRAVED BY T. JOHNSON.

From "Harper's Monthly Magazine."

manage so difficult a branch of art should commit such utter failures in even the simplest landscape. It may be that the vagueness and easy inexactness of much landscape drawing is not permissible on portraits. Certainly the best work, by far, in *Harper's Weekly*, as in other newspapers, is to be found in the portraits. Kruell's stand out as the best of these. From his best I choose the portrait of Mr. Fletcher Harper, given with this writing, which seems to me all that can be desired: bold, without being coarse, — form, color, and tone well cared for, — the drawing everywhere good, and differences of substance well distinguished. I find another portrait, almost as good (by Kruell and Reuter), in Vol. XXI., for 1877, — a portrait of Dr. Muhlenberg, — the only fault in which is that the fur of the dress, etc., has not the texture of fur. Good cuts, also, of figure subjects there certainly are, beside the portraits; but too many of them only good so far as daring disregard of traditional rules may be called good, — not good in an engraver's judgment, — good, if it be good to get over the ground quickly, careful only to keep color and to please the draughtsman by catching the eccentricities of his handling. Prominent among such I may name [I content myself with a single specimen, not chosen with any personal reference] the *Milkmaid's Song*, engraved by T. Johnson, from a drawing by Howard Pyle, in the number for July 19, 1879. The engraver, I suppose, had his instructions; and I can also believe that his engraving is a very faithful and close representation of the drawing. Nevertheless, it seems to me, as engraving, utterly weak, inexpressive, and inefficient. The engraver has sacrificed himself to the "artist," the artist who seems to have cared rather for the unessential manner of his work than for the real object of the work itself. A good dashing Bewick-like cut, also by Johnson, *A Warning to City Visitors*, after Reinhart, No. 1079, September, 1877, shows what the engraver could do when opportunity offered.

I take such engravings as that of the *Milkmaid's Song*, and *id genus omne*, to be done under the dictation of young painters, who not unnaturally presume that their especial manner and affectation are of more importance than methods of engraving, concerning the laws and necessities of which they are profoundly ignorant. It is no new thing. I recollect that I once executed an engraving [the verb may require executioner instead of executor] for which I received an offered double payment, on which I was sorry to be employed, and of which, when finished and approved, I was heartily ashamed. The drawing was by Millais, subject *Cleopatra*, for an illustrated Tennyson. Unlike some later painters, he had drawn it most carefully on the block with pen and ink, that there might be no mistake; and it did not seem unreasonable in him to insist that his lines should be exactly adhered to. Only he was not aware, or did not think, that even his ink lines had variety of color, and that the engraving would be printed of one uniform blackness. He was satisfied with the result: I considered it only as a piece of unsightly mechanism. Knowing better than he did the capabilities of my own art, I could have rendered in one third of the time all that he sought for, *except the unessential*. The essential he lost in seeking for what was worthless. It is no new thing, this deliberate preference of the

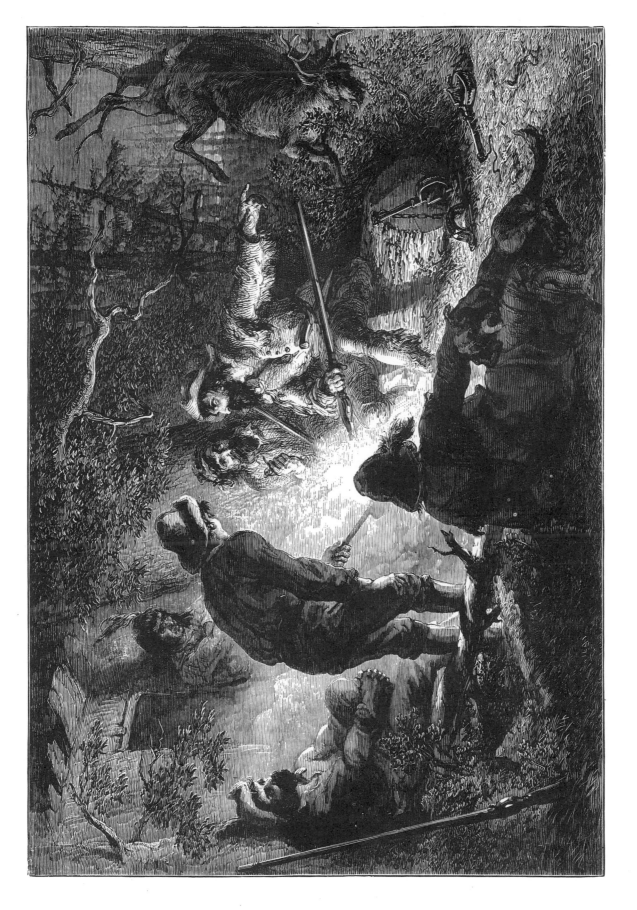

HUNTERS AND TRAPPERS IN THE WEST.

DRAWN BY F. W. O. DARLEY. ENGRAVED BY W. J. LINTON.

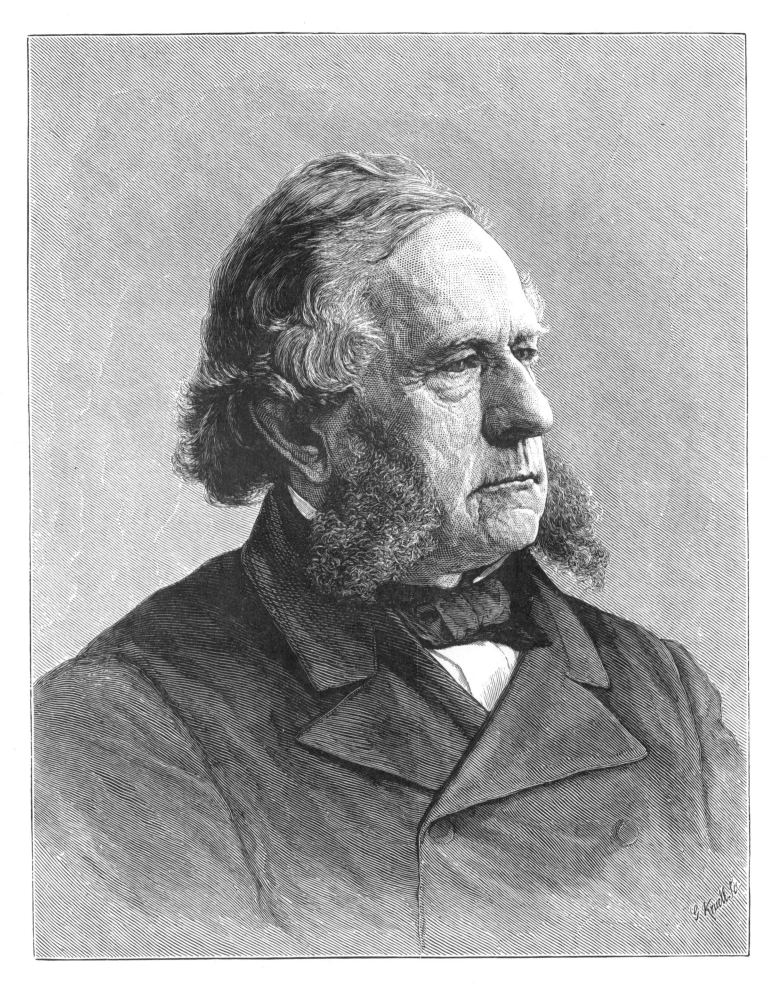

PORTRAIT OF FLETCHER HARPER.

ENGRAVED BY G. KRUELL.

FROM HARPER'S "WEEKLY."

AN AFTERNOON IN AUGUST.—ENGRAVED BY MORSE.—FROM A PAINTING BY A. QUARTLEY.

From "American Painters," by G. W. Sheldon. Published by D. Appleton & Co

less important, though the fashion in this country be but set of late. Not that due attention to even the least important is to be disregarded; only let it be *due* attention. Nor has all that is undue arisen from the presumption of the untaught draughtsman. Part has come, as before said, from the desire to do something beyond what has been already done. Given the same men, and no new talent, it might fairly seem that excessive fineness was the one point on which they might excel. Cole, Smithwick, Johnson, Juengling, Davis, Bogert, [I am not ill-naturedly picking out names, nor meaning any hint of depreciation,] all could and did work in a bolder style than that lately prevalent. Vigorous and masterly work by them is to be found on the pages of *Harper's Weekly* and the *Aldine*, and in cuts done for the American Tract Society. Shall we say that the new demand for always fineness, fineness above everything, is only a fashion,—the new requirement of over-attention to unessentials only a passing fancy? It began to sprout about 1875 or 1876. Some of the manifestations of this fashion, or fancy, have been good. King's engraving of an *Alley in Chinese Quarter*, San Francisco, (drawn by Abbey as neatly and precisely as anything by Moran,) in Scribner for 1875 (page 281), is excellent, and not too fine for the subject. Fineness also was necessary in Müller's *Signing of the Declaration of Independence*, after Trumbull, and in the same engraver's *Penn's Treaty with the Indians* (Scribner, 1876), the last an admirable work in every respect, the other not improved by some cross-lining too evidently done to save the trouble of lightening the tint first cut. But in later works, after Abbey's drawings [I am in no way reflecting against his talent as a designer, while criticising his manner of drawing on the wood] and in engravings from drawings by Pyle, Church, Reinhart, and others, of the new school of designers, I find not only an appearance of too great desire to be yet finer than the last scratchiness, but the continually increasing subserviency of the engraver to, not the knowledge, but the ignorance or the capriciousness of the draughtsman. I take hold here of two recent works, not for the

ENGRAVED BY ANTHONY.

From "Landscape in American Poetry."
Published by D. Appleton & Co.

sake of fault-finding, but because what I have to say of them will more forcibly explain my meaning.

Surely Mr. Clarence Cook's *House Beautiful* (Scribner, Armstrong, & Co., 1878), dealing mainly with bedsteads, tables, candlesticks, and other household furniture, needed not the combined talent of Mr. Lathrop, Miss Oakey, and Mr. Marsh, only to produce an affectation of fine imitative etching and careful pseudo-artistic rendering of even empty space behind the furniture to be represented. "Why not?" says, perhaps, my reader. "Why not, if art may be rightly employed in beautifying even the meanest thing?" But my objection is not to the artistry, but to the pedantry which calls itself artistic. The picture of a chair or a bedstead, a sideboard or a curtain, does not require an elaboration of cross-lining, not only in the object itself, but in the space surrounding it. It is no better for the elaboration. And along with this pretension of conscientious art, this dogmatic assertion of the importance of every line drawn by the designer, however clumsily or undesignedly, I find, with an utter disregard of all that an engraver would value in manipulation, a disregard also of even tolerably correct drawing. No. 17, a *Friendly Lounge*, and No. 18, *Now do be Seated*, may serve as instances. Neither lounge nor chair has any nicety of construction: both, whether from the artist's inability to draw or from the engraver's over-scrupulous respect for that infirmity, are rude, and have a look of being damaged or worn out. Indeed, both are out of drawing. But then the formless shadow of the chair is cut with most accomplished Chinese exactness; every line of the drawing has been preserved; and with the same slavish dutifulness the engraver has followed the lines marking grain of wood upon the wall. Grain, I suppose; but it is so emphasized (literalness sometimes caricatures) that it has more the appearance of the rough-hewn and partially split wood of some log-hut, rather out of character with the "beautiful" cushioned lounge. I take these two cuts at random: they are by no means exceptional specimens of the style. There is not even the beauty of mechanical correctness in the drawing; and the engraver has consented

to what he should have known was bad.

But those who would see the worship of the unessential in all its glory I must send to the *Boys' Frois-sart* (Scribner, 1879), a book for the text of which, indeed, Mr. Sidney Lanier and the publishers deserve the especial gratitude of Young America. Let the examining engraver, however, as he sees the cuts, wonder at the thorough contempt for anything like meaning or beauty of line there displayed. Clouds, smoke, stone walls, flesh, ground, drapery, all things supposed to be represented, are jumbled together in most admirable obscurity (difficult as it is in wood-engraving to accomplish the obscure), as if the lines had been drawn in sand and shifted by a whirlwind; or perhaps the engraver did it in his sleep, dreaming he had an impression of the designer's meaning.

Contemporary Art in Europe (1877) and *Art in America* (1879) contain the best of work in *Harper's Monthly*, as Scribner's *Portfolio of Proofs* (1879) has the pick of *Scribner's Monthly* and *St. Nicholas*, — the

STUDY FROM NATURE.

ENGRAVED BY HOSKIN, AFTER A. B. DURAND.

From "Art in America," by S. G. W. Benjamin. Published by Harper & Brothers.

Proofs most carefully printed, showing the cuts to the best advantage. Here I am again confronted with the new style, — what I have (I hope not unfairly) characterized as an endeavor at excessive fineness, to the sacrifice of what is most essential in engraving, intelligent drawing. I have, even so judging, to acknowledge not only the talent of the men so employed, but also the excellence of very many of their works. In speaking severely of particular cuts, I am not necessarily denying the ability of the engraver. I entreat my readers to limit their application of my strictures to the stated subject of the same; and again and again to recollect that, even where condemnation may appear to be general, there may be exceptions. If already I have spoken somewhat sweepingly, it has not been without intention of amends, which I shall have very largely to make in reviewing the works now before me.

Art in Europe and *Art in America* are so much of the same character as regards engraving that it is needless to review both. I may content myself with notice of the latter work (Harpers, 1879–80). No list of engravers is published; I am obliged therefore to pass by some cuts which might else deserve notice. Two of the best, here given, may speak for themselves: Hoskin's *Study from Nature*, after Durand (page 61), — very sound and delicate, the feeling of the painting admirably given; and J. P. Davis's *Whoo!* (an owl and rabbits,) after W. H. Beard (page 87), — bird, beasts, and landscape well cut, with nice discrimination of substance. I do not, however, see any value in the cross-lines on the sky; and there is a patch of perpendicular crossing under the owl which to me is utterly meaningless and offensive. I point out these faults because they are blemishes, the only portions to be objected to in a

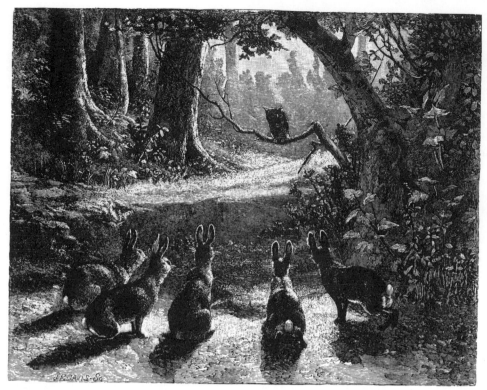

WHOO!—ENGRAVED BY DAVIS, AFTER W. H. BEARD.

From "Art in America," by S. G. W. Benjamin. Published by Harper & Brothers.

very excellent engraving; also because I think Mr Davis too good an engraver to need the aid of so slovenly a method. He could have obtained all the delicacy and lightness he required with pure and simple lines. The same fault occurs yet more flagrantly in other cuts to which, but for that, I could have given unqualified praise: Annin's *Altorf* (page 64); and *The Scout* (page 126); Müller's *On the Sod* (page 127); *Birds in the Forest* (page 169), by Smithwick & French. In this last the birds are remarkably good; but the cross-lining behind is unsightly, and the unreturned lines give a dirty look to the whole. There is a good cut by the same engravers (page 55), *A Surprise*, after William Sidney Mount. Hoskin has two capital cuts, *On the Kern River* (page 99), with a pure and firm line and good gradation of tone, and *Beverly Beach* (page 63), very delicately rendered; Kruell has some first-rate portraits; Harley, a *Winter Scene* (page 84), excellent and refined. Wolf's clever engraving from a clever sketch by Reinhart, *Washington opening the Ball* (page 175), gives us an extreme specimen of the new "impressionist" treatment: trowel-work and brush-marks, daubs and scrapings of color, instead of drawing; and definition of form left out everywhere except in the two faces. Smithwick & French, in their literal fidelity to Abbey's *Astonished Abbé* (page 187), could not but caricature the absurdity of the drawing, though the mere chiaroscuro is perfectly kept. And Juengling's *Bit of Venice* (page 185) is remarkable for a twisted sky, which elsewhere might pass for a crumpled kerchief: probably true, however, to the drawing or photograph he had to stick to. Other cuts deserving of remark I reserve till I review *seriatim* the work of the more prominent of the engravers who to some extent have proclaimed their adhesion to a new style of treatment. The work by various hands in late numbers of *Harper* and *Scribner* requires consideration, which can be more fairly given by attention to the engravers severally. Its merits and demerits are both of sufficient importance to deserve most careful weighing.

CHAPTER VII

F the Harper and Scribner men, the men who constitute what may be called the New School of Engraving on Wood, Mr. Cole, I think, stands fairly at the head. That he has knowledge and command of line is clear, even by reference only to his early work in the *Aldine*, and in the *Christian Weekly* and *Child's Paper* of the American Tract Society. *A Mother of Egypt*, drawn after Bonnat by J. S. Davis (*Aldine*, Vol. VII. p. 382, January, 1874), is full of force: the lines of the flesh decided, one might say harsh; but with good attention to form, and with thought of direction of line as expressive of form. The dress, dark and fine, has texture as well as drawing; the background is firm and well-toned. Another engraving by him, after Merle (also in the *Aldine*), has the same qualities of form, color, and texture, if parts are perhaps not quite so good. And now to look at his later doings.

The first of the series of portraits by which his name has been made prominent appeared in *Scribner's Magazine* for October, 1877: a head of *Hjalmar Hjorth Boyesen*. This was followed, in the next number, by a portrait of *Lincoln*, and, later, by portraits of *Bryant, Long-fellow, Emerson, Holmes, Whittier*, and others. These portraits at once attracted attention, admiration, and adverse criticism. They deserved all. They are remarkable, not only for unusual fineness, but as endeavors at new results in wood-engraving. They are admirable as specimens of minute and careful mechanism, as the work also of an artist conscientiously making the best of what was given him to represent. They yet are open to criticism. The *Lincoln*, in a different style from the rest, has the look of a reduction of a poor pen-and-ink drawing, in which, however good the likeness, the draughtsman had not command of his pen. It is a drawing which any practised draughtsman on the wood could have done better; and the engraver's chief, if not only, merit is that he has well preserved even its weakness. The other heads have been differently treated. Photographed on the wood, I suppose, the engraver has lost himself in trying to catch the manner of the original crayon: not to be caught, for one process can never exactly reproduce another. The drawing else is in its essentials very admirably repeated. The *Boyesen* and the *Holmes* are not only wonderful examples of microscopic handling; but the first series of lines in them is good, as line; and only softened, not obliterated, by after crossing. Still the effect of the over-elaboration is to make the portraits foggy, to destroy variety of substance (the hair of the *Holmes* being of precisely the same quality and texture as the flesh and the shirt-collar), and to give the whole cut rather the appearance of some phototype from a steel plate than of a wood-engraving: a result not quite desirable. In the *Whittier*, the engraver returns toward the ordinary method of engravings, in his cross-lining not so much disturbing the first series of lines. It is, however,

READY FOR THE RIDE.

ENGRAVED BY T. COLE, AFTER W. M. CHASE.

From "Scribner's Monthly Magazine."

weaker than the rest; the hair is still hardly to be called hair, and the dress and background are meaningless tint, not even expressing color. The *Longfellow*, the *Emerson*, and the *Bryant*, all of the crayon intention, look like bad lithography, unsatisfactory unless indistinctness be a merit. Nevertheless, the main faults of these portraits, after seeing the originals, I may not lay to Mr. Cole's graver. Beside having to forget the capabilities of his own art in a vain attempt to imitate the unpleasant peculiarities of another, he had also to represent vagueness, by no means easy to do with definite lines. Mr. Eaton himself says (*American Painters*, page 173) that in the *Bryant* portrait he "aimed to give prominence to the principal fact of his character, to reproduce that which was most really Bryant, — to portray the real form of his head and the life that issued from his eyes. Everything was kept subordinate to the sense of that life; *every detail of the hair and the flesh was generalized, hardly a wrinkle of the face was preserved*." In the words I have underlined I find the excuse for Mr. Cole's short-coming. He had to engrave the *subordination*. In the original drawing no more than in the engraving can I see either the principal fact of Bryant's

character or the form of his head. There is only a fat-cheeked, fluffy face, such as might be caught a glimpse of at a spiritual *séance*. In the interest of art, can one be too severe, if just? I turn with pleasure to the better, because more artistic, work which Mr. Cole has given us.

I can best observe this in Scribner's beautifully printed *Portfolio* of selected proofs. The best of these by Mr. Cole (it is impossible to notice all) are, it seems to me, *Madame Modjeska*, Vedder's *Young Marsyas*, St. Gaudens's *Adoration of the Cross*, and Chase's *Ready for the Ride*. *Modjeska as Juliet* (*Scribner's Monthly*, Vol. XVII. p. 665), engraved from a photograph, is very perfect: extremely fine, but not unnecessarily so: the line on the face firm and yet delicate, the details of the white dress admirably preserved, the line nowhere offensive, but helping to express both form and material. Some want of clearness in the shadows is evidently owing to the printer; but on the whole it is a beautiful piece of engraving (I would call it Mr. Cole's best), one worthy of any engraver of the old time. The *Young Marsyas* (*Scribner*, Vol. XVIII. p. 169), drawn on the wood by the painter, is even more minutely lined than the *Modjeska*, and suffers therefore: ground, hares, and trunk of the tree under which Marsyas is piping, lacking distinction of substance. As showing how fine work, well cut, may be clearly printed, it may however be counted a success. And the figure of Marsyas is thoroughly good. Against the alto-rilievo after St. Gaudens (Vol. XV. p. 576) I have but one objection: the needless variation in direction and character of line, which gives a false appearance of material, as if the

work were composed of stone and wood and calico, instead of one homogeneous substance. *Ready for the Ride* (Vol. XVI. p. 609), if not so ambitious as some other subjects, may be spoken of as faultless. The dates of the above, not noticed in choosing them, suggest a steady improvement in the engraver. Of other subjects, such remarks as I have to make do not lessen my appreciation of Mr. Cole's ability and talent. In the *Carrying the Boar's Head* (Vol. XVIII. p. 702) the two heads are admirably done; but the rest of the picture has the same fault that I found in the *Marsyas*,—want of character in the line, insufficient distinction of substance. The light and shadow is excellent. *Italian Fisherman's Hut*, drawn by Mrs. Foote (*Scribner*, Vol. XVI. p. 452), suffers from the weakness of over-refinement, though general effect and color are well kept. It is difficult to distinguish water from earth; the cliffs are unsubstantial; and the distances between near and far objects are altogether lost. There was no fault here in the drawing. Mr. Cole does not succeed with Mrs. Foote's drawings. *Santa Cruz Americana*, hers also (*Scribner*, Vol. XVI. p. 456) [Note the dates in our comparative judgments], has lost all the manner and all the charm of the original. In *Walden Pond*, by Homer Martin (Vol. XVII. p. 504) he has done better. The poetic feeling of the drawing is well preserved. It is not better for the cross-lining. In Page's *Sisters* (*St. Nicholas*, Vol. VI. p. 145) the heads are excellent; the rest of the engraving is feeble, scratchy, and formless. Whistler's *White Lady* (*Scribner*, Vol. XVIII. p. 489), very carefully engraved, yet more careful on account of the uncertainty of the photograph, does not aid my recollection of the picture. The weakness of Fortuny's *Piping Shepherd* is due, I have no doubt, to the original. The engraver had no right to contradict the master artist. And yet I think he had a right to set the *Griffin at Work* (Vol. XVII. p. 461) upon solid ground, although Mr. Abbey had sketched him in the air. There is a limit to the subserviency of an engraver (stalwart or wooden); and surely the sketch did not indicate a necessity for perpendicular cross-lines in the sky. All these cuts my readers will find in the *Portfolio*, as well as in the Magazine. Enough of critical fault-finding: not spared, because Mr. Cole can well afford to bear it. He has in him the potentiality of a great engraver. Only let him be not afraid to have clear ideas of his own as to what is best to aim at; and be careful to avoid mannerism, the maggot which eats out the core of greatness. He need fear no competition if he be true to his opportunities.

Though I have placed Mr. Cole at the head of this new school, Mr. Juengling is its most remarkable exponent. With his name also, in *Harper's Weekly* and the *Aldine*, I find the larger work; but even in that, bold and vigorous enough, the tendency to sacrifice form and meaning to mere chiaro-scuro, of which I am always complaining. A portrait of *Edison in his Workshop*, drawn by Muhrman (*Harper's Weekly*, Vol. XXIII. p. 601), may emphasize my meaning. The picture is effective and vigorously drawn. Edison is working at a charcoal fire. The rays of light are just as solid and tangible as the man's hair, while a glass bottle on the bench is as woolly as his coat, which again is no woollier than his face. In a small or hurried work no difference of material had perhaps been looked for. But in this front page of the paper, very elaborately engraved, with endless cross-line, black and white, we have a right to expect definition, detail, and some expression of material (not only of the material of the drawing, which may have been only a copy or photograph of our favorite crayon drawing, but of the differences that do subsist between light and hair and wood and glass and wool and flesh) The want here noted is, as it seems to me, the continued want in all Mr. Juengling's most clever work (clever as it certainly is, however unsatisfactory), not hidden even by the superfineness of later years. I would prefer (but needs of criticism compel) to pass over his Kelly cuts, with the greater part of the block covered with an utterly useless ruled tint (I say ruled because it is as mechanical as if ruled), and the lines on the rest of the engraving in defiance of all ordinary laws. I confess that it may be only conventional sheepishness that orders us to represent level ground by level lines; but it is hardly more reasonable, however independent, to try to represent the same with perpendicular lines—not even crossed. See *Scribner* for 1878,

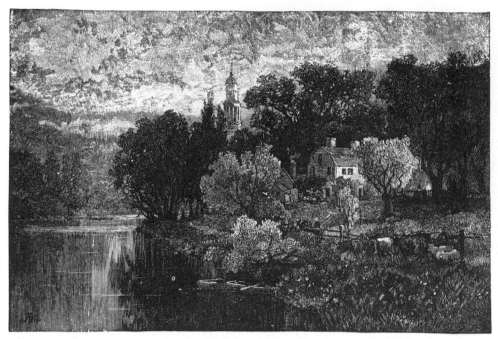

THE PARSONAGE. — ENGRAVED BY F. JUENGLING, AFTER A. F. BELLOWS.

From "Art in America," by S. G. W. Benjamin. Published by Harper & Brothers.

Vol. XVI. p. 680, *Dropping Corn*, Juengling after Kelly, — figures walking up a perpendicular wall, like flies on a pane of glass. See also the otherwise tasteful bits of landscape by Abbey on pages 1, 4, and 5 of *Harper's Monthly* for June, 1879, excellently cut wherever the engraver was content with simple lines, spoiled wherever he had opportunity for cross-hatching; the draughtsman's carelessness of anything like completeness in his work serving perhaps as warrant for certain obtrusive masses of the vague, patches of unsightly cross-lines, horizontal, perpendicular, and diagonal, which may mean sky, which may also be only a representation of those parts of the block free from the artist's pencilling. The most curious instance I find of this incompleteness is in another Juengling, after Howard Pyle (in the same June number, page 71), where half the block, without drawing, is yet covered with engraver's work of this same meaningless character.

I take Mr. Bellows's *Parsonage* (*Harper's Monthly* for September, 1879, page 468, also in *Art in America*, page 75) as the best piece of landscape work I know of with the name of Juengling attached. It is a very beautiful cut, at first sight. The effect is capital; it is evidently very true to the original; and I do not even quarrel with the perpendicular lines on the water. They here help to give transparency. Let it be allowed that there are exceptions even to the best rules, and that in art all means are right which produce a good result. The cut, I say, at first sight pleases me. But looking more closely, as an engraver and critic must, I am sorry to observe that trees, grasses, and cows have all too much the appearance of being made out of chopped hay. And what can I say of the sky? The color is good; it looks well a little way off: but we are tempted to examine so fine and finished a piece of work. It is a cloudy sky, but there is not a cloud in it. It is all patches, and, taken separately, might pass for imitation of — a quilt. If Mr. Bellows did so draw — I mean paint — it, I think the engraver might still have been a little pleasanter in his lines. Yet I admit that for ordinary magazine purposes and for an uneducated public it may be pronounced admirable and perfect.

With the portrait of *Whistler* (*Scribner*, Vol. XVIII. p. 481, — in the *Portfolio* also, which I believe is considered Mr. Juengling's *chef-d'œuvre*), as an engraving, I have no fault to find. As a portrait I had not objected to two eyes. But if the painter was content with one and a socket, and with paint in place of drawing, it had surely been impertinent in the engraver to have emphatically contradicted him. Paint, to the very sweep of the brush, never was better reproduced on wood than in parts of this cut. Notwithstanding, I might suggest that the cheek has the look rather of wood than of paint.

The *Whistling Boy*, after Currier (*Scribner* for May, 1880, page 11), may have the same excuse for being as the portrait of Whistler. Even Mr. Currier's admirers allow his work to be ugly. The utter contempt for modelling in the face and the disregard of drawing everywhere are, I have no doubt, most faithfully rendered by his engraver; but surely Mr. Currier had not

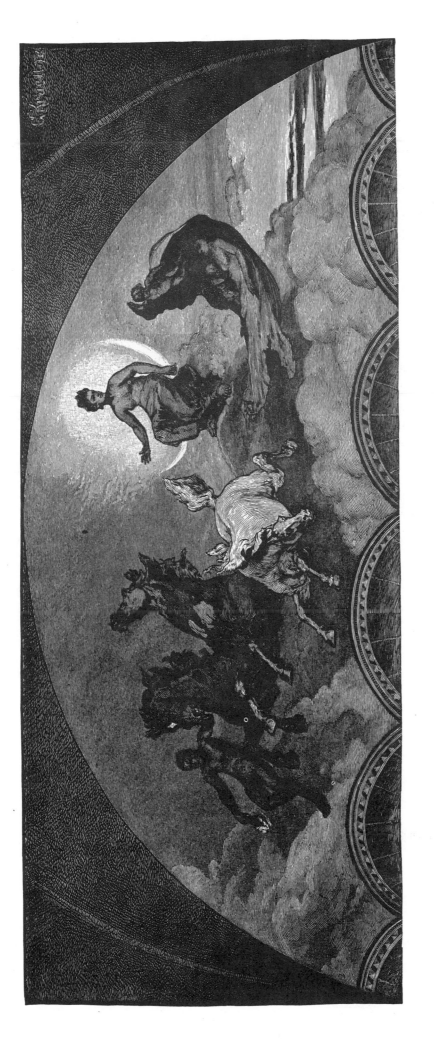

THE FLIGHT OF NIGHT.

DRAWN AND ENGRAVED BY G. KRUELL, AFTER WM. M. HUNT.

FROM "THE AMERICAN ART REVIEW."

WILLIAM CULLEN BRYANT.

ENGRAVED BY T. COLE. DRAWN BY WYATT EATON.

FROM SCRIBNER'S MONTHLY.

time to draw the cross-threads of that white shirt, far too white for that dirty, slovenly boy.

Is it Mr. Lathrop's careless drawing, or only the Juengling manner, that we have again in the portrait of Edison (*Scribner* for October, 1879, page 840)? Here even the brush-marks are a failure, more resembling clumsy wood-carving. The likeness may be correct; but anything more weak and unpleasant as an engraving I have not found. Am I too hard upon the Juengling method? I think not, free to confess that there too is talent, which may be turned to good account if the engraver's (or his patrons') eccentricities can be got rid of.

Very different is the treatment of a head by Mr. Kruell. I have already praised his portrait of Mr. Fletcher

JAMES A. M. WHISTLER. — ENGRAVED BY F. JUENGLING.
FROM THE ORIGINAL, BY WHISTLER, IN THE POSSESSION OF MR. S. P. AVERY.
From "Scribner's Monthly Magazine."

Harper, in *Harper's Weekly*. Another portrait of Mr. Harper, after Elliott, came out in Vol. LIX. of *Harper's Monthly*, and reappears in *Art in America*. It deserves the same unmixed approval as was given to the larger head: form and effect well cared for, no meaningless or offensive lines, every line *drawn* with the graver, the face well modelled and made out, though not a fourth of the size of the Juengling heads already noticed. Granted some difference in the drawings, the different intention as well as the different method of *the engraver* is no less apparent. I suppose there may be brush-marks in Elliott's picture, some manner also, to be caught if important. But Mr. Kruell has been careful not to caricature such small matters, — has cared rather, perhaps only, to give us a noble portrait, a good likeness, a picture to satisfy both painter and critic. This, and not the expression of accident or whim, seems to me to be the true end of art. So aiming, I am not surprised that Mr. Kruell's portraits are always good. This head after Elliott and a portrait of William Morris Hunt (*Harper's Monthly* for July, 1880, page 163) will compare favorably with Mr. Cole's *Modjeska;* and are superior to Cole's *Victor Hugo* (*Scribner*, December, 1879): I might object to their exceeding fineness; but I can find no other fault with them. Perhaps with so good and clear engraving even that fineness is not a fault. Again, comparison may be made (this for the sake of contrast) of these heads, or of a portrait of *William Howitt* by Kruell (*Harper's Monthly*, May, 1879, page 853), with two por-

WILLIAM HOWITT. — ENGRAVED BY G. KRUELL.
From " Harper's Monthly Magazine."

traits of *Bayard Taylor* (*Scribner*, November of same year).

The *Howitt* head and Cole's *Taylor* are engraved in the same manner, what I may call the old manner, of lines laid with care for regularity and pleasant disposition, as in a steel " line-engraving." Mr. Kruell's *Howitt* head is the more regular, somewhat more formal perhaps; but with more decision and more attention to differences. The beard of the Cole (*Taylor*) head is not hair, but floss-silk. The Juengling *Taylor*, distinct from both, is but a clever scratchy imitation of a piece of bronze. Here again the essential has been sacrificed to the unessential. It is bronze-like, rather than like the work of the sculptor O'Donovan. By exact attention to the minutest scratch it gives, I suppose, a tolerable resemblance of the original, close except for the art left out. And here it may be worth remarking (not, however, with reference to Mr. O'Donovan) that the artists who most insist on the value of their own most careless and unimportant impressions are the very men who require, not an impression of the same, but strict attention to the smallest details, however vaguely hinted at,

however unintelligibly impressed. Mr. Kruell is not prone to this imbecility. His hand is too vigorous for stencil-work. Other admirable portraits by him I could enumerate; but enough are already mentioned to show his quality. I may not, however, pass a noble head, the *Dauphin*, after a steel engraving from a painting by Greuze (*St. Nicholas*, Vol. VII. p. 1; in the *Portfolio* also).

Nor is his work confined to portraits. The *Young Princes in the Tower* (*St. Nicholas* for February, 1880) is excellent in every respect. Careful in drawing, clear in definition everywhere, delicate, with strength and depth of color, clean in line, and pure in tone (I speak of it from a proof before me), — it reminds me of the best of Adams's work, not without indication beyond of the advantage gained by the more ambitious attempts of later time. Not so delicate as this, but more characteristic of the engraver's normal style, is the capital rendering of Vedder's *Phorcydes* in the June number of the AMERICAN ART REVIEW (here given), a piece of vigorous artistry in which Mr. Kruell has no rival. Especially I admire the flesh of the three figures, and the good drawing (so often wanting) of hands and feet as well as faces. Other cuts by him in the AMERICAN ART REVIEW, — the portrait of *Barye* (No. 1, p. 13) and the copies of Hunt's *Flight of Night* (also here given) and *The Discoverer*, — I may refer to as further indorsement of the praise that appears to me to be his due. Mr. Kruell, I may add, has no mannerism to get free from, unless it may be called mannerism to follow any rules whatever. With his healthy tendencies and the power of hand he has shown, I think he may be trusted even to make experiments. He will not quarrel with me for saying some more variety would not hurt him.

CHAPTER VIII

Y age Mr. Marsh is anterior to the "New School." Yet, with genius that should have taken him otherwhere, he has led to it and leans toward it. He has been handicapped by his entomology. Artist in feeling, and capable engraver as he is, yet —

> Let him handle his graver wherever he will,
> The butterfly shadow hangs over it still.

I have already done homage to his incomparable insect work. He stands, with all his talent, as a warning against mannerism: though in fairness it must be said that the greatness of his mannerism was thrust upon him, and was not only excusable, but justified by necessity. But the law of consequence halts not for justifications. His one solitary exception to the prevailing manner, so far as my knowledge goes, (and I needed proof to convince me it was his,) was the *Robinson Crusoe* given at page 32. I gave it to show what he might have done had not his course continued from beetles to La Farge, from La Farge to beetles again. "Nous revenons toujours à nos premiers amours." Mr. La Farge's drawings (I speak here only of his manner of placing upon the wood his most imaginative designs) were most unfortunate practice for Mr. Marsh. The broadest Nast drawings, to correct his tendency to subtlety and over-refinement, had been better for him. "No more minuteness" should have been his motto: instead of which, his reverence for the higher qualities of La Farge's work made him the slave of all its deficiencies in execution. Those Riverside drawings, — the *Wolf-Charmer* and others of that La Farge series, — original, labored, and suggestive, were yet of real detriment to the *engraver*. They, rather than the insects, may be considered the beginning of the "New School." He builded worse than he knew. Submissive toward his artist, painfully conscientious in his work, there is yet nothing in them to be valued by an engraver. Four other drawings by La Farge for *Songs of the Old Dramatists* (Hurd & Houghton, 1873) have the same conditions. The one here given is, I think, the best specimen we have of Marsh's talent, great, but belittled. See how daintily he has treated the figure, how full of delicacy and feeling is the principal flower. But the figure does not float over the stream, — it sticks against the unreceding water; and the distant leaves and flowers are as close to you as is the foreground. It is the same in everything. There is no distance. Beetle or butterfly texture always, and generally confusion. *A Simple Fireplace* (F. Lathrop), *Aloft on the Glittering Shield* (Mrs. Foote), *Little Sigrid* (John La Farge), *Still Life, Study in Oil* (R. S. Gifford), — all remind us of the *Insects injurious to Vegetation*. In the *Still Life* we are in doubt as to what is flat and what in relief, and whether the vase holds feathers, or flowers, or both, so confused are the over-labored textures. Of course he is perfect in an *Etruscan Fan* of feathers, and a little bas-relief of *The Author of Home, Sweet Home*, is very pure and charming. For all these I refer my readers to the *Portfolio of Proofs,*

ENGRAVED BY HENRY MARSH.—DRAWN BY JOHN LA FARGE.

From "Songs of the Old Dramatists." Published by Hurd & Houghton.

rather than to the pages of *Scribner's Monthly*, that my strictures may not be laid to the charge of any inferior printing. I have, perhaps, been severe on Mr. Marsh's short-comings, but surely not from any personal prejudice. There is an important question involved in the differences I am noticing,—a question of truth or falsehood in work, a question be it only said of better or worse in the methods of engraving, which I am endeavoring to bring out and clearly to explain. It is an important part of the History of Wood-Engraving in America.

A bold double-page cut, before referred to, by J. G. Smithwick, from as bold a drawing by Reinhart, will repay the trouble of looking to pp. 88, 89, of *Harper's Weekly Journal* for 1877 (Vol. XXI. No. 1049). It is a daring piece of genuine white-line work, in which, with no lack of self-assertion on the part of the engraver, the drawing and manner of the draughtsman have been fairly reproduced. It is as bold (coarse would not be the right word for it) as Anderson's boldest, and truly in the style of Bewick, if with less determined drawing. It is this larger work which shows the engraver's power. Where excessive fineness comes in there is but little room

for distinguishing manipulation. Matters not, the workman may say, what lines come here; they will be too fine to be noticed. So he fills in his space, as he might if he had a stencil-plate, with anything; and it passes if he but keep the color. Looking at this Smithwick engraving, one wishes the engraver might always find employment on this larger scale. He has, however, admirably adapted himself to the smaller needs of book and magazine work. Good cuts by him will be found in *Harper's Monthly* for 1878–79, one very good, after Miss Jessie Curtis (Vol. LVII. p. 805). At p. 816, Vol. LVIII., he has dropped into the cross-line inanity, where I should be loath to leave him. He is too strong to linger among the handmaids of Omphale. Reynolds's *Strawberry Girl* (*St. Nicholas*, Vol. III. p. 345) and *Miss Penelope Boothby*, the frontispiece to the same volume, (both also in the *Portfolio*,) show him in his manlier style. Another work of his I would particularize is the *Adoration of the Cross* (*Harper's Monthly*, Vol. LVIII. p. 672, *Art in America*, p. 160), drawn by Snyder, after St. Gaudens, the same subject and of the same size as Mr. Cole's, remarkably like that in treatment, and equally good. A *Haystack*, after Swain Gifford (*Scribner* for 1878, Vol. XVI. p. 516), and a *Little Cove at Nassau* (Vol. XV. p. 28), are fair specimens of his ability in landscape; and of his small figures I may choose for praise his copy of the *Surprise*, after Sidney Mount (*Harper's Monthly*, Vol. LIX. p. 251, and *Art in America*, p. 55). His figures are generally good. *Flags, eh?* (*Harper's Monthly* for July, 1880) is a fair example. But what does he mean by that mass of net-work under the horse and cart? It makes a positive substance of the shadow, the end of

MODJESKA AS JULIET.

ENGRAVED BY T. COLE, FROM A PHOTOGRAPH.

FROM SCRIBNER'S MONTHLY.

it sticking to the dog's head. A little clean outlining (too much neglected under the stencil system) would have prevented other near and remote parts of the cut from sticking together. And what is the use or beauty of that ridiculous cross white line in the ground?

I have spoken only of Mr. Smithwick; but Mr. French's name should be coupled with his partner's in many, if not in all, of the works I have here noticed.

THE HAYSTACK.

ENGRAVED BY SMITHWICK & FRENCH. — DRAWN BY R. SWAIN GIFFORD.

From "Scribner's Monthly Magazine."

The double-page cut in *Harper's Weekly* is, I suppose, by Mr. Smithwick only.

Mr. F. S. King seems to have an affection for birds and fish, as well as for landscapes, though he is able also in figures. *On the Edge of the Orchard*, by Swain Gifford (*Scribner*, Vol. XVI. p. 513), is thoroughly good. So also is the *Sea Raven and Toad-Fish*, by J. C. Beard (Vol. XIII. p. 589). *The Birthplace of John Howard Payne* (Vol. XVII. p. 472), "from a charcoal drawing," carefully labored, has the look of a poor lithograph or process "engraving." The *Bobolink*, an earlier work (Vol. XII. p. 488), is bright and excellently cut. Mr. King knows how to

FLAGS, EH?

ENGRAVED BY SMITHWICK & FRENCH. — DRAWN BY A. B. FROST.

From "Harper's Monthly Magazine."

MODJESKA.

ENGRAVED BY F. S. KING, AFTER CAROLUS DURAN.

From "Scribner's Monthly Magazine."

give value to his blacks; for which I may refer also to the *Plaza at Retaluleu* (Vol. XV. p. 621). The *Return from the Deer Hunt* (Vol. XIV. p. 519) and *Morning at Jesse Conkling's* (Vol. XVII. p. 460) are as good specimens of fine landscape engraving as I have seen anywhere. The first, a snow scene, is very striking; the figures in it are also well cut. The same may be said of the figures in *Snowballing* (Vol. XVII. p. 39). *Snow Buntings*, by Miss Bridges (Vol. XII. p. 485), another snow scene, is equally good, and for difference of style may be contrasted with Marsh's *Humming Birds*, by Riordan (Vol. XVII. p. 161), — the difference between clearness and bewilderment, — perhaps in some measure owing to the drawing. All these engravings by Mr. King will be found in the *Portfolio of Proofs*. I refer also to the magazine for the benefit of those who have not the proofs; also because the magazine references show the order of time in which the works were done. Other notably good works by the same hand are the *Modjeska*, after Duran (*Scribner*, Vol. XVII. p. 668), as good in its way, if not so important an engraving, as Mr. Cole's *Modjeska*, at p. 470, with which it may be well to compare it; and a marvellously elaborated *Peacock's Feather* (*Harper's Monthly*, Vol. LVII. p. 384, 1878), capitally drawn by W. H. Gibson, a cut altogether worthy of Marsh. *Butterflies* (Vol. LIX. p. 385), by the same artist, do not equal those by Marsh, but are good, though the cut is spoiled for want of distinction

between the butterfly texture and the texture of the flowers. Mr. King's tints, whether of sky or of ground or water, are full of tone, pure in line, and sweet in gradation. I would praise especially a cut in *Harper's Monthly* for 1879 (Vol. LIX. p. 13), a ghostly figure by Abbey, exceedingly fine in cutting, the flesh nicely stippled, the gauzy drapery well rendered, and the color, ranging from solid black to the positive white of the lightning, excellently emphasized and gradated: the whole very painter-like and effective. And yet one more must not pass unnoticed, — the *Falls of the Blackwater* (*Harper's Monthly* for July, 1880, p. 181), than which I know of nothing more truly refined, more pure and delicate. I only quarrel with fine work when it has nothing but fineness to recommend it. Fine as this cut is, the graver drawing is good throughout.

Mr. Hoskin's landscapes have the same delicately discriminating quality as those by Messrs. King and Smithwick & French. I know his work only in *Harper's Monthly*, and in the reprint, *Art in America*. The cut I have given at page 47 is a fair specimen of his ability. *On the*

THE PHORCYDES.

ENGRAVED BY G. KRUELL, AFTER E. VEDDER.

FROM "THE AMERICAN ART REVIEW.

Kern River (*Art in America*, p. 99) is very good: the line firm, with excellent gradation and tone. Other of his work I may conveniently notice in the number of *Harper's Monthly* for September, 1879 (three cuts at pp. 484, 485, and 487). That after Casilear is of his best, not bettered by those useless perpendiculars again in the sky; the Hubbard is weak, yet more weakened by still worse perpendicularity; and in the *Sunset on the Hudson*, Sandford R. Gifford, what might have been an excellent piece of tone is spoiled by the same lazy offensiveness. I say lazy, because it seems to me that much of this cross-lining is done only to save the trouble of considering direction of lines in the first place, or of thinning too thick lines when the effect requires that. I set it down as generally a mere trick of laziness. I make amends to Mr. Hoskin for this remark, by no means aimed personally at him,

THE MOWING.

ENGRAVED BY H. WOLF. — DRAWN BY ALFRED FREDERICKS.

From "Art in America," by S. G. W. Benjamin. Published by Harper & Brothers.

by calling attention to another of his works, the *Old Mill* (*Harper's Monthly* for July, 1880, p. 174), to which, save for still a slight glimpse of my perpendicular *bête noire*, I am happy to give unstinted praise. I find that I have picked out three cuts from that last July number of *Harper* for especial commendation. There is, indeed, a remarkable amount of good work in it, as there is in most of the later numbers of the magazine, — one especially good, *The Errand*, by Johnson (p. 52, June, 1880), — mixed unfortunately with much that is poor or bad. Is there no such monster as an editor with pictorial judgment?

Mr. Wolf is not to be overlooked, but I must now be content with choosing a few cuts indicative of the engraver's ability. He answers to the roll-call of the New School, and what I have already given of that may suffice without much further illustration. The *Mowing* (*Harper's Monthly*, July, 1879, *Art in America*, p. 165), though over-elaborated [there was no occasion for the cross-threads on the girl's dress, and her face and some of the herbage are of the same fabric], is else a good cut. The *Start Viva* (*Scribner*, Vol. XVII. p. 713) is not without merit: but why (I am always on the same quest) are distant wall, flat ground, drapery, dust, and horse-hair all apparently worked in cross-stitch? *Seeking Pasturage* (Vol. XVII. p. 480) has

THE START VIVA.

ENGRAVED BY H. WOLF. — DRAWN BY G. INNESS, JR.

From "Scribner's Monthly Magazine."

good graver work in it. Is it the draughtsman's fancy that the starved sheep are all woolless? I guess it is but another case of the perhaps artistic engraver sacrificed to the unartistic idleness or incapacity of his draughtsman. Much cry on the designer's part, but no wool! These two cuts will be found also in the *Portfolio*. A very noticeable Wolf will be found in *Scribner* for May, 1880 (p. 5), *Feeding the Pigeons*, after Walter Shirlaw. The cut is very delicately gray, with fine accentuation of the blacks in the pigeons. But everything is flat, without distance or definition of form. Patches of the girl's dress, her cap, her face, distant wall, pigeons' backs, — all are of the same material. Look also (in the same number, p. 7) at *Oyster Gatherers*. The sky may be torn sail-cloth, or blocks of ice, or bad wood-carving: there is not even the shape of cloud. Supposing this to be the painter's whim, one does not the less feel it to be a degradation that for any reason whatever an engraver should be compelled to repeat it.

Has imitation of lithography become the *beau-idéal* of Mr. Müller? His *Banito and his Pet* (*St. Nicholas*, Vol. VI. p. 80), in the *Portfolio* as an example of his style, would seem to imply so much. "Drawn by Mary Hallock Foote": yet not a suspicion of her pencilling is there. Was it a rough sketch, reduced for the magazine, a loose vignette, and then squared out with a gray background of machine work? Her design is there, but nothing of her dainty hand-work. And yet the New School prides itself in exact reproduction of brush and trowel marks, and perfect imitation of artistic touch, from charcoal to pen and ink. Mr. Müller has done better things, already referred to. I notice this cut, not so much for rebuke of *his* apparent tendencies, as to point out what may fairly be expected under the present unintelligent *régime*. *On the Old Sod* (*Harper's Monthly*, October, 1879) will do more justice to Mr. Müller. But those lazy perpendiculars again! And in *A Sing on Monhegan Island* (p. 345, *Harper's Monthly* for July, 1880), why are the walls and ceiling plastered with cobwebs? Is it characteristic of the Maine islands?

I must hasten through my task of criticism. There is no use in multiplying instances. Mr. J. P. Davis, like Mr. Marsh, is one of the older men. But his style has changed with the times; or, rather, he has lost his earlier style through following the conceits of others. *Cradling*, Tiffany (*Scribner*, Vol. XIV. p. 529), and *Roxy*, Walter Shirlaw (Vol. XVI. p. 792), sufficiently indicate his recent work. *Mr. Charles Coghlan as Charles Surface*, Abbey (Vol. XVII. p. 777), may show how far he has wandered. One of his best landscapes is here reprinted from

DARTMOUTH MOORS, MASS.

ENGRAVED BY JOHN P. DAVIS, AFTER R. SWAIN GIFFORD.

FROM "THE AMERICAN ART REVIEW."

the AMERICAN ART REVIEW. Color and general form seem excellently kept; but the foreground lines are meaningless, and I can see no reason for the complication of lines in the sky. The tone of the whole is, however, of admirable quality. One thing to be noticed in all this superfine work is, that, however diverse the original genius of the men, when they are drilled into superfineness their work is scarcely distinguishable. This utter subordination of the engraver destroys his individuality. Having no individuality of his own, will he be better able to appreciate the individuality (the real personality, I do not say only the outer clothes) of the painter? J. H. Whitney does a perfect piece of patient facsimile in his cut of *Joe* (*Scribner*, Vol. XVIII. p. 491, and *Portfolio*). In endeavoring to reproduce *The Morning Stars*, after Blake's wonderful etching (*Scribner*, June, 1880, p. 237), he has simply attempted an impossibility. For his very failure, however, he deserves much credit. It is remark-

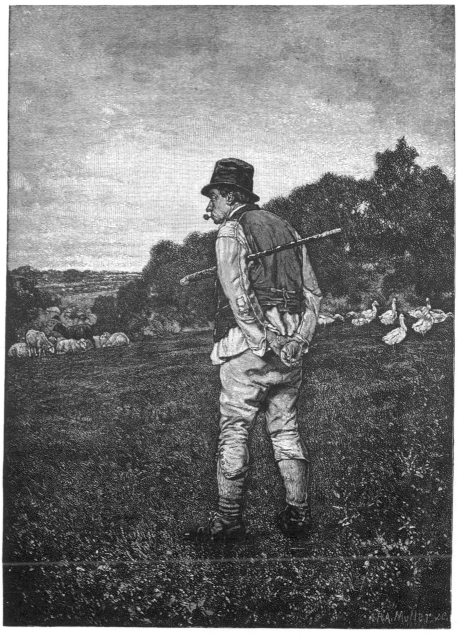

ON THE OLD SOD.

ENGRAVED BY R. A. MÜLLER, AFTER WILLIAM MAGRATH.

From "Art in America," by S. G. W. Benjamin. Published by Harper & Brothers.

ably close to the original. The Haden etchings (*Scribner*, August, 1880) are failures altogether as representations of the larger etchings. They only give the subjects of the originals. I must point to one more example of the Microscopic,—Leblanc's reproduction of the frontispiece to George Cruikshank's *Table-Book* (*Scribner*, Vol. XVI. p. 172). If this sort of thing be—can it be?—carried further, Messrs. Harper and Scribner will have to atone by endowing a hospital for blind wood-engravers. And still another calls for notice,—Mr. Kilburn's *Sand Dunes* (*Scribner*, July, 1880, p. 365). I certainly do not give it as a sample of Mr. Kilburn's work, but as the crowning mercy of the "New School." I can best describe it as *a Juengling by machinery*. May I hope that Mr. Kilburn has invented a machine for the saving of our threatened sight?

To what are we tending? I have carefully examined, I believe, everything that has been done by this new school, whose works both grace and, I think, disgrace the pages of our two most enterprising, most liberal, and most deservedly successful magazines. I think I have not been slow in recognizing talent, nor stingy in awarding praise. But how much of the talent is misapplied: for I can but call it misapplied when it is spent on endeavors to rival steel line-engraving or etching, in following brush-marks, in pretending to imitate crayon work, charcoal,

or lithography, and in striving who shall scratch the greatest number of lines on a given space, without thought of whether such multiplicity of line adds anything to the expression of the picture or the beauty of the engraving. Talent! there is no lack of it. My list of capable engravers has left out many, and I have but given a few samples of a vast amount of work. Possibly it will seem to some that they have been neglected, that such and such engravings at all events should have had honorable mention. So should it have been had there been no limit to my history. It had been a pleasure to have honored even the youngest of the rising men, to have done fuller justice to those known. After all, the melancholy reflection would have been but the more deeply impressed upon me, — How much of talent is here thrown away, how much of force that should have helped toward growth is wasted in this slave's play [call it gladiatorial, and own yourselves hired or condemned to do it], for a prize not worth having, the fame of having well done the lowest thing in an engraver's art, and having for that neglected the study of the highest! For it is the lowest and last thing about which an artist [and it is only to the artist-engraver that I care to appeal] should concern himself, this excessive fineness, this minuteness of work. It might have its worth, though there not so important as it seems, in the copying of old missals [see illustrations to *A Famous Breviary*, in *Harper's Monthly* for February, 1880]; at least it is not out of place in work such as that, better befitting the indolent hours of monks than the stirring lives of men who should be artists. I do not say there is no good in it. While acknowledging its cleverness, I recognize also something to be gained, — a niceness of hand that may be usefully employed. But in engraving, as in other branches of art, the first thing is drawing; the second, drawing; the third, drawing. Form, beauty of form, and place — perspective and distance: until you can express these, you have not even the beginnings of your art. When you have mastered these, and with many or few lines can make these understood, go on to differences of substance, and beauty and harmony even of lines. After which you may refine as much as pleases you, provided you do not destroy intelligibility or strength. I know no surer recipe for making good engravers. It is all drawing with the graver, or it is not engraving at all, — not worthy to be so called.

I am aware that there is another method, — the mechanical, the Chinese, the stencil-plate method. You can take your choice: either to trust to your own understanding, or to grow a pig-tail, and follow your "artist" blandly in Chinese fashion. The second may for a time be the more profitable, as well as the safer method, and will certainly be most pleasant to any number of young painters or designers of vagueness, your want of understanding dovetailing into and assisting theirs. I say this is the safer method; for an independent understanding, or say only a respectful endeavor to do something that may be understood, will possibly lead you astray. I have heard of an engraver, and one of fair age and reputation, who, striving to make something out of his painter's touches of white, engraved a stream with foam-edged waves; and lo! the artist intended it for a field of daisies. Over the just wrath of that artist, who might have prided himself on his botanical correctness, I draw a hasty veil; but the unhappy engraver — has gone about with a pig-tail ever since. The misadventure might fairly warn him off too conceited a dependence on himself; and yet I think his course of action, fail as it might in certain instances, was the right course after all. And he has found draughtsmen on the wood, and painters also, who thought his engraving better for his understanding of what they drew or painted, and who were not too arrogant to allow that he, better than they, might know the opportunities and limitations of his own art.

And here let me confess to my brothers in engraving afflictions, that, however hardly I may have dealt with them in these my criticisms, it has been, in the first place, not from desire to censure, but out of an earnest wish for their benefit and the improvement of our art; and, in the second place, I have borne in mind a saving clause. Not they, the engravers, have chosen to bow down to brush-marks, to blind themselves with what soon will be altogether unprintable

work; but it has been brought into vogue and forced upon them by ignorant reviewers, unde-signing photographers, and the malice prepense of painters who, too idle or unable to draw upon the wood, have deceived unwitting publishers into the belief that they were inventing "a great invention." It will have its day, and then, with what we can save out of the failure, we shall return to the old traditions, not renouncing experiment, but also not abandoning or slighting the experience of some who have gone before.

I carefully review the works I have had before me for this history. I can find nothing so good [and let it be remarked that it was as fine as most of the fine work of to-day] as the *Jacob's Dream* engraved by Adams nearly half a century ago (see page 13). It is better than the best of all work since done, better than the best so much extolled at present: because he did not sacrifice everything to fineness, but cared first for the essentials of good drawing and lines with meaning, and finished only after laying the foundations.

I would not part from my readers without at least brief explanation of the course I have pursued in the foregoing History, — or shall I rather call it Preliminary Study of History as part-preparation for some completer volume. Concerning the earlier men I have had for almost all my material to depend upon personal recollections of men often strangers to me, to whose ready courtesy I here acknowledge my great obligations. Sometimes reports so collected have not agreed, and it has been difficult to judge between conflicting statements. I may not always have been correct in my judgment. I am hopeful, however, that it is only in minor and quite unimportant matters that I shall be found astray. There may be errors, too, in my writing of my contemporaries: some wrongful attribution of work; omissions also. But I may conscien-tiously affirm that I have rejected no information of any worth volunteered to me; and that I have sought for information wherever I had the slightest hope of reaching it, — in more and in stranger quarters than I can here afford space to give account of.

For my critical opinions I can truly say this: they have had no personal bias. Very often I have chosen the subject for comment, and written my criticism, before knowing who was the engraver. It was a secondary inquiry — second in time if not in importance — whose name I had to affix to it. If (I have already pleaded to the possibility) my remarks have sometimes seemed harsh or out of tune, I ask of the engraver who may read them to forgive any cause he may find for momentary wincing or disgust: bearing in mind his own regard for the healthy progress of our art, for which I confess myself very jealous. I have not written merely to sup-ply a dry chronicle of the doings of American wood-engravers; I have written, in praise or blame as seemed just to me, distinctly from a desire to help the advance of wood-engraving in America. I trust the true lover of the art will generously pardon any short-comings and even some offences for the sake of our common object.

CHAPTER IX

THE reprint of my History as a whole gives me opportunity for reviewing what I have written, and of atoning for certain omissions in the same. There may be some novelties also calling for consideration. To two men especially, owing chiefly to the necessity for economizing the space at my command, I did not quite do justice; and a third, so far as I could ascertain, had not at the time of my writing put in an appearance in his own name. The first two are Messrs. Kilburn and Davis, of whose work I am now able to give fairer specimens (from recent numbers of the AMERICAN ART REVIEW); and the last is Mr. Closson, a younger aspirant for engraving fame. Of his work and Mr. Davis's I shall have to speak at length. Other names not known before I may here take note of, as I gather them from the lists of engravers in late numbers of *Harper's Monthly Magazine*. It is a new and fair action on the part of the publishers to give this credit to the engravers in their employ. The next advance will be for the engraver's name to be always put to his work. He cannot readily be identified by merely reading the list in the table of contents. In these late numbers, good work by known men — Kruell, Harley, Smithwick & French, Hoskin, King, and others — I find very creditably companioned by the work of Williams, Tinkey, Hellawell, Brighton, Winham, Deis, Grimley, Schelling, Smart, Delorme, Tietze; and I may yet omit names worth mentioning in a catalogue of engravers. If I do not particularize any, it is because there is no one exceptionally characteristic. All are on a tolerably even level, their work more careful and finished than we were in the habit of seeing in magazines, — sometimes, also, not always, better as art. The best of recent cuts in *Harper* are, I think, those of *The White Mountains*, from Mr. Gibson's excellent drawings. *Black and Tri-Pyramid Mountains*, by Harley, and *Franconia Notch*, by King, both in this August number, are of the best, if not the best. The snow on Mr. Tinkey's neat cut of *Mount Lafayette*, in the same number, is very successfully rendered: none the better for its excessive fineness, notwithstanding which, however, it prints admirably. But I need not return to general criticism of our two Magazines, which continue the even tenor of their way, neither falling off nor improving, the *ne plus ultra* of fineness seeming to be reached in both, and no great new departure toward Art as yet to be recorded. Yet I would call attention to one cut (certainly not meaning that it is the only one worth attention) in *Scribner*, as a hint, and I hope a promise, of healthful growth. Following some very careful engravings of *Marine Forms* (some by Leblanc, other names I do not read), there is one of the *Lobster at Home* in this last June number, in which I find what I am so long vainly looking for, — *a line drawn by the graver*. Would the reader know exactly what I mean, let him, or her, look to the *Lobster Pot*, at page 209, engraved by F. S. King. The cut is as fine and delicate as the finest that has appeared in *Scribner*; but the rock and water are really distinct substances, and the lobsters

DENGLER, DUVENECK, AND FARNY, IN THEIR STUDIO.

ENGRAVED BY S. S. KILBURN.—FROM A PHOTOGRAPH.

From "The American Art Review."

have the form and texture of lobsters. Form, color, substance, are perfect: to fitness of line is added beauty of orderliness and intention, which mark the accomplished engraver; and it is at once vigorous and delicate. The fineness here is not without its charm. It were a good lesson for one desirous of learning what engraving is (which I would briefly define as a process of drawing with a graver) to compare, say rather to contrast, this with other cuts in the same June number;—the *Canners*, at page 214, or the *Boiling-Room*, page 216; the page cut of *Joan of Arc*, from Lepage's picture; the *Village Spring*, page 169; the scrap of "sculpture" at page 161; or the more important bas-relief at page 230. Surely it were as easy to represent a stone surface as a shell; but this engraved sculpture is not stone. Distances might have been shown at pages 169, 214, and 216, as well as in the *Lobster* page. Yet in the cuts on these three pages, and in nearly every other cut in the number, the distant objects are on the same plane as the near ones. It is the naturally concomitant fault of the imitation of photographs. *Joan of Arc* has expression and color: good, so far. But flesh, drapery, and formless background are all cut with the same poor, combed-out, inexpressive line; and there is more artistic power, more drawing (I hope that term may now be understood), in one of Mr. King's lobsters than in *Joan of Arc*, or the "bronze" *Farragut* either, on page 165. I do not know by whom these cuts were engraved. I speak of them only as engravings happening to lie handy for my remarks.

Something of the same weakness observable in all these cuts I find also in Mr. Davis's beautiful cut of *Eager for the Fray*. I do not hesitate to call it beautiful: a more beautiful piece of hand skill, in some respects, is not to be seen in these pages; but it lacks the drawing

I admire in the *Lobsters*. Not merely cavilling, nor grudging praise, but to teach, I point out what it wants. The face would be excellent, if the lines were not crossed with such ugly rectangularity. The better arrangement of line on the boy's left leg and foot, both admirably cut, will show more precisely what I mean. The body has the same fault as the face, and, what is worse, is formless. Why are the left arm, which is in full light, and both hands, darker than the shadowed sides of the rest of the limbs and body? Is engraver or painter answerable for this? In the trees I pick out as a fault the indistinctness and want of precision. Else *the line* of the trunks is good, being expressive, having the look of bark. The dog, too, is well rendered. But background and foreground are all of equal vagueness; and the boy's shirt might be — anything, for all it has of texture or substance to help your perception. It is only a lump of unsubstantial formlessness, a mass of ugly lining, not a fold in it, nor any shape, drawing, or intention. The turned-up portions of the trousers are equally formless. All this is bad, unartistic. With all this there are qualities of tone and delicacy, and even determination of line, in parts, which show that correct drawing alone is wanting to make the whole a fine work of art. Lacking form, it seems to me to lack everything, in spite of all its dexterous and dainty manipulation. If, however, as seems to be contended by many, accuracy of drawing is not needful, the mere pleasant first impression all that is required in an engraving, then this cut is perfect. Unsatisfactory to the critic, it may please and satisfy the easier public.

I am glad to be able to give unbated praise to Mr. Closson's excellent rendering of Mr. George Fuller's lovely picture of *Winifred Dysart*. Here even the extreme fineness is of value. I know not how else the engraver could have done justice to the delicate subtlety of the picture. Though I have spoken severely of indiscriminate fineness, I do not the less recognize its occasional and certain value. My objection has been to the preference given to mere fineness over power and expression; or, shall I say, to its use for the sake of hiding feebleness or meaninglessness of line. Fineness (I cannot too often or too emphatically insist) is not necessarily refinement, and except as refinement has no sort of value whatever. To represent by ten lines what could be better done, or only as well done, by five, is waste of labor and ridiculous excess, — is not art, however triumphant as mechanism. There can be no possible correct judgment of engraving, nor indeed of painting or sculpture, without the thorough recognition of this distinction. As I have written elsewhere, (but the matter will bear much repetition,) "It is a mistake to suppose that fineness (closeness and littleness of line) and refinement (finish) are anything like synonymous terms. There is such a thing as propriety, — suitability not only to size, but to subject, in the treatment of an engraving. A work may be bold even to the verge of what is called coarseness, yet quite fine enough for the purpose, — by which I do not at all mean the purpose of the publisher. Also it may be finished and refined, however bold: in which case to call it coarse simply because the lines may be large and wide apart would be only misuse of words." Vedder's *Sleeping Girl* is not less finished than the portrait of Mr. Chase on page 68; but I would have thought myself foolishly wasting time had I engraved it with the closeness of line appropriate to that.

Truly may fineness be out of character with the subject. "Take some landscape strong in opposition of color, — a wild, tempestuous scene, large and vigorous in treatment. The painter has flung his paint upon it, left the coarse marks of his half-pound brush and the mighty sweep of his trowel. He cares not for that, — need not care; seen at a proper distance the effect is what he desired. What would you say to the engraver who should so far disregard the bold carelessness characteristic of the painting as to give you in niggling minuteness every brush and trowel mark, in order that, or so that, you may forget the real worth of the picture, despite the painter's breadth and vigor and absolute disdain or dislike of finish, in your admiration for the engraver's most delicate and neatest handling? 'See how grandly broad the rendering of that cloud!' (It is perhaps the painter talking to himself; or is it the accomplished literary critic discoursing learnedly on matters of unknown art to an admiring crowd?) 'A momentary

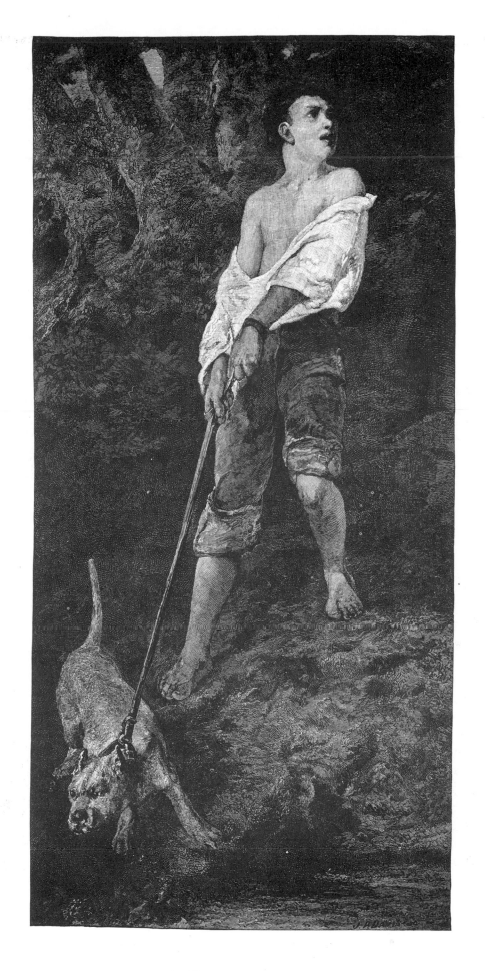

EAGER FOR THE FRAY.

ENGRAVED BY J. P. DAVIS, AFTER WALTER SHIRLAW.

FROM "THE AMERICAN ART REVIEW."

WINIFRED DYSART.

ENGRAVED BY WM. B. CLOSSON, AFTER GEORGE FULLER.

FROM "THE AMERICAN ART REVIEW."

MAGDALEN.

ENGRAVED BY WM. B. CLOSSON, AFTER DR. RIMMER.

FROM "THE AMERICAN ART REVIEW."

SLEEPING GIRL.

DRAWN AND ENGRAVED BY W. J. LINTON, AFTER E. VEDDER.

sketch! instantaneous as a photograph! exceedingly effective! No, it could not be improved by any additional care in modelling, or by any gradations of shade or color. Only view it from such right distance that you are not disturbed by the carelessness of the manipulation.' Says the engraver, or his work for him: 'Never mind the cloud or anything else of the picture! See how admirably I have imitated the crossing of the brush-strokes! Notice the shadows of the blobs of color left where the palette-knife laid it on! You can tell at a glance which is brush-done and which is knife or trowel work.' Is that the purpose of engraving? Labor, even skilled labor, can be ill-bestowed. And if, after all this trouble about brush-marks, you have lost what drawing there was in the picture, missed the very spirit and grandeur of the land-scape, while busied with those little sprigs of mint and anise in the corner, how shall your engraving be called *fine*, in any artistic sense, though it needs a microscope to enable me to count the lines? What wonderful eyes, what dexterity of hand, must have been in requisition! But, after all, it is not *a fine engraving*. Fine as an artist's word is not the same as in the proverb of the feathers. Fine feathers may make fine birds, but *fine lines only* will not make a fine engraving. The one is the French *fine*, thin, crafty, not exactly honest: from which are many derivatives, such as *finasser*, to use mean ways; *finasseur*, a sharper; *finasserie*, petty trick, poor artifice; *finesse*, cunning, etc. Quite other is the masculine *fin*, the essential; from which we get *finir*, to finish; and *finisseur*, a finisher or perfectioner. And the first *fine* is the very opposite of the old Roman *finis*, the crowning of the work. The artist does care for finish, that is, for the perfectness of his work; he is below the real artist, and will reach no greatness, whenever he can be content with the *unfinished*. But the word *fine*, the proper adjective for a great work, was taken, perhaps unaware, by poor engravers, careful mechanics without capacity for art, as a cover for their deficiencies; and, accepted by ignorant connoisseurs, now passes current, for the beguilement of trusting publishers and an easily bewildered public. So trick is admired instead of honest art workmanship.

"An engraving is *fine*, meaning *good*, in so far as art, as distinguished from mere mechanical dexterity, has been employed upon it, is visible in the result: visible, I would say further, even to the uneducated, if not already vitiated by the words of misleading critics. The art of an engraving is discoverable, even by the uninitiated, in the intention of the lines. You may not have an artist's quickness of perception, nor his maturer judgment; but if you see an engraving, of which the parts, any of them taken separately, are unintelligible, you will rightly suppose that the engraver did not know what he was doing, or how to do it. Do not believe that the work is good for anything, though you read the most impartial and unbought recommendations of many a newspaper! Art is a designing power. If you can find no proof of that, reject the work as bad!"

I am not losing sight of Mr. Closson's engraving, for my words have reference to that. I admire his work, not because it is fine (in the sense of close and minute and many-lined), but because such fineness (minuteness) was necessary for his subject, and because, close and deli-cate as his lines are, he has not lost determination and force; because I can see throughout his graver-work intention and feeling, and that the lines stand closely for the sake of expression, are not merely huddled together in ignorance of handling. He has sacrificed nothing of value in caring for the exquisite finish of his work. Wherefore it is a work of art. I can hardly give the same praise to his *Magdalen*, at best a good imitation of a phototype, — such imitation a very doubtful sort of success. Some excuse I can find for the attempt in a desire to produce as nearly as possible a fac-simile of the original drawing. The phototype process would have done that better. I think that my friend Dr. Rimmer, with his clear judgment of the essentials of Art, would not have cared for this, would have been well content, perhaps more pleased, to have seen a broader treatment. But I will not too much blame what may have been only the weakness of a conscientious timidity. Mr. Closson's evident earnestness in his work will in due time teach him how to dare and, daring, to excel.

WILLIAM M. CHASE.

ENGRAVED BY G. KRUELL. — FROM A PHOTOGRAPH BY KURTZ.

From "The American Art Review."

Two recent clever and important works by Mr. Juengling — *The Professor*, after a picture by Mr. Duveneck, and *The Old Peasant and his Daughter*, a copy from the German painter, Leibl (AMERICAN ART REVIEW) — challenge consideration. Of the *Professor* I frankly confess that the first sight was very pleasant to me, so good is the general effect. Further examination did not increase my pleasure. Yet I allow what seems to me a faithful and very close imitation of the original. Even the texture of the painting appears to be admirably rendered. The expression and color I should believe to be as true. Is not that enough? Not quite. That said, I have to say further, that the truth and fidelity are of the Chinese sort, not disparaging the mechanical skill of the engraver. But it is mechanical, and not artistic. I must contend that, whatever respect may be due to a painting, the engraver's business in rendering flesh is to make it like flesh, and not like only

paint; always premising that the painter, notwithstanding all paintiness, did intend to give an appearance of flesh. Is it too much here to suppose that Mr. Duveneck was not altogether careless of that, and possibly did intend, if not achieve, something of the sort? Would it then have been too great a liberty in the engraver to have carried out such intention, and given us flesh, instead of only *a painted board?* Is there any hair on the Professor's head, or has some lad amused himself with cutting notches in the block? Two terrible cuts over the Professor's right ear, and an awful gash, almost severing the left ear from his cheek, may be so done in the painting, but have an ugly appearance in the engraving. Has he lost a great portion of his beard and moustache, or does it only happen that, upper lip, shadow of nose, shadowed

cheek, eye, hair, coat, and background, being all of the same wooden texture, there was no occasion by any difference of line to distinguish one from another? There is no drawing in any. And notice how awkward and inharmonious are the lines of the face in the lighter parts. Except the ear, which is not an ear at all, and the patched eyebrows, the modelling here is generally very good, and the effect, I repeat, is capital. Was the work too fine to add some beauty of line? Compare it with the portrait by Mr. Kruell, here opposite to it. The Kruell head is smaller, and the work is minute; but the lines are pleasant, and in accordance with the forms they represent, helping the representation, which Mr. Juengling's lines do not. One would think that he has no sense of fitness of line, no perception whatever of lineal beauty, or that some eccentricity makes him averse to any lines that are sweet and graceful. The one head is the work of an artist; the other, perhaps more clever, only shows a remarkably skilful mechanic. Throughout the one work there is a feeling of beauty and fitness, of which I cannot find a trace in the other. I like not to draw such comparisons; but better not to criticise at all than to shirk the truth. The all-important distinction I have noted may be yet further observed, if my reader will look back to Mr. Johnson's *Mozart*, at page 44, and to Mr. Kruell's *Fletcher Harper*, on the opposite page to that.

The Old Peasant and his Daughter, for all its elaboration, equally dissatisfies me. Carefully elaborated it certainly is; the color and general effect of the picture are, I have no doubt, well kept, the expression of the faces also. But again I have to ask: May not even peasant's hands and faces deserve as accurate definition as — the claws of those kingly lobsters of which I lately spoke? Is that a hand behind the girl? Compare, again, with Mr. Kruell's! Is it flesh, that scabbiness on the back of the hand which rests upon the chair? Shall glass, cloth, and flesh, have no variety of line to mark their difference of substance? Mr. Juengling lacks not command of his graver: why does he allow it to run so wildly astray? Or, again, is he the victim of a false theory, — that fidelity to the painter may supersede all faithfulness to Art and truth? I ask these questions, not captiously, but necessarily, lest I, too, fail to prefer a critic's duty — of outspoken censure, when censure seems required.

Here, also, lies the whole question between myself and what has been called the New School: yet not new, for the same faults have been long existent, though never so ostentatiously exposed. I have been reproached with jealousy of a new departure. There is little novelty except in the defence and attempted justification of the departure, — the old departure from artistic conscientiousness, for the sake of a temporary popularity. And for that fidelity to the painter which, in season and out of season, is so much insisted on, I may say this: that I have a right to the credit of first insisting on attention to the painter's or draughtsman's individuality, and that in work with my name to it of more than thirty years ago will be found the first endeavors in that direction. But the painter is not all. The engraver should be also an artist, not less than a translator, something more than a copying machine. And although he has no right to thrust himself, or say his manner, in the place of the painter's, yet the mere effacement of all individuality in him will not necessarily enable him as an accomplished copyist.

One thing I notice in this new acquirement of self-abnegation (the Chinese method, as I must continue to call it): that is, the ease with which it degenerates into simplest mannerism, so that all men's work becomes alike unmanly, and engraving after the new pattern may almost be taught in the traditional "six lessons." Am I exaggerating? Let *Scribner's Magazine* bear witness for me. Here before me is the number for April of the present year, with its trumpeted prize engravings: the first by a boy, aged sixteen years, whose time of practice had been only two years; the second, after six months' practice; the third, after fourteen months. The second of these prize engravings is too weak to be worth notice; but the first and third may rank fairly with the average cuts in the Magazine. There is the same minuteness and infirmity of line as in the usual work of the "new" photographic school, whose indistinct and indistinguishable mannerism is most unhappily described as remarkable for "a variety of refined,

rich, unhackneyed styles, never before seen in the history of the art." Is that art which can be so readily mastered, which can be so easily learned by boys and the rawest experimenters? The question answers itself. I accept gratefully the involuntary confession that this experiment "to a notable extent has revealed and confirmed the characteristics of the new school type." And I can go further in confirmation. I have under my eyes at this writing the *second attempt at engraving* of an entirely unartistic but enthusiastic amateur. A thoughtful, patient, handy man, he has wonderfully done his cutting. It is fine, clean, line for line to the photograph on the wood; but it is pure mechanism, there is not a touch of art in it. With this before me, indorsing the *Scribner* prize experience, I feel confirmed in my judgment, — in which perhaps some few engravers will bear me out, — that "the three commanding characteristics of wood-engraving in the United States at the present time" *are not*, as asserted in *Scribner* (April, 1881), either "originality," or "individuality and variety of style," or "faithfulness in the reproduction of a wide range of subjects by diverse methods." On the contrary, I affirm that, owing chiefly to the servile following of photographs, individuality has been weakened, faithfulness become Chinese, and the "art" more monotonous than ever. Variety of subject is not the same thing as variety of method. The only originality I find, in a method borrowed from England (where the same viciousness was in vogue before *Scribner* began), consists in adding to the old utter neglect of the necessary fitness of line to the object it would represent a reckless and defiant, I will not call it daring, disregard of all lineal beauty and orderliness, — a departure to be admired only so far as we may admire the "art" of those painters who pride themselves on cheap slovenliness and impressive trowelling. There is nothing worth calling originality in this, nor anything of individuality in the wide range of feeblenesses in imitation of "diverse methods." One method cannot to any good purpose imitate another. Wood-engraving is not better for looking like steel or crayon. I am not defending an old "rut," because I praise not the new "departure." These experiments, valueless in themselves, I have already said, may yet have use. They compel some nicety of hand, and train, if they do not educate, the eyes; and this will some day be turned to better account, — nay, is of advantage already to men not enslaved to manner, — such men as Messrs. Kruell, King, and Closson. I name them because in this present writing I have had occasion to notice their work.

Minuteness of work also has compelled renewed attention to printing. For all which, while in some measure thankful, I am again at issue with the editor of *Scribner* in his advocacy of dry paper. Dry paper, certainly, if you cannot get your paper properly damped, — not else. This dry paper, also, is no *Scribner* novelty. Indeed, the Magazine is well printed (I did not think that on dry paper such a result could be obtained), but that does not prove the *superiority* of the process. Dry printing suits the Magazine, its paper, and its cuts; but I could show better printing of old time, before the adulteration of tinted papers rendered it inexpedient to damp them, wherefore for publishers' economical reasons the old good plan had to be abandoned. Dry paper also suited the vulgar "taste" of the French printer, who delights in a disgustingly high polish upon his paper, with the blacks in full glare. Books from the "Chiswick Press," printed always on damp paper, show a finer result, and from finer engravings, than anything of to-day. I could point even to some *early* printing of the *Illustrated London News*, not yet beaten, if matched, by the finest specimens of magazine or book work upon this side.

To sum up my criticisms in few words, removed from personality. I have not objected to any novelty merely because new. An experimenter myself, my life through, I do not lean to too much respect for conventions or established systems. But I have learned, even while experimenting, that it is not given to any one, even in engraving or printing, to make such new discoveries as shall warrant him in despising all the knowledge of the past. Our young men may be wiser than their elders, and yet we will not quite believe that our fathers were all fools. Change, I can allow, was needed from the mere conventional methods which are abundantly represented in these pages. But the change that was needed was a return to the old

THE GOD OF WINE.

DRAWN AND ENGRAVED BY W. J. LINTON, AFTER F. BARTH.

FROM APPLETON'S "ART JOURNAL."

THE OLD PEASANT AND HIS DAUGHTER.

ENGRAVED BY F. JUENGLING, AFTER W. LEIBL.

FROM "THE AMERICAN ART REVIEW."